INTRODUCTION

Soon after the War of 1812 ended, bringing a close to Indian hostilities in northern Ohio, settlers from New England and New York began to take farmland in what would become Sheffield Township. Originally known simply as Township 7 of Range 17 of the Western Reserve, in 1815 two men from Sheffield, Massachusetts, Militia Captains Jabez Burrell and John Day, purchased the township, encouraged friends to join them, and began to clear the land for their farms.

Harrowing stories of the pioneer families as they trekked through the wilderness to create our communities are filled with determination, perseverance, and willingness to overcome nature's many obstacles. By 1824, when Lorain County, Ohio was formed and the township was officially recognized as Sheffield, 44 families occupied farms on the land bordering the Black River and French Creek valleys.

Eager settlers were attracted to the fertile land as Sheffield's first century moved on. As the dense forests were cleared and swamps were drained, fields of wheat, rows of corn, and lush pastures replaced them. Sawmills, gristmills, churches, and schools were built and lake schooners were launched along the river. Men like Robbins Burrell and Capt. Aaron Root joined the abolitionist movement, hiding runaway slaves at their homesteads and carrying them in ships to freedom in Canada. Others, like Henry Garfield, sought adventure in the gold and silver fields of the West, some returning with fantastic tales of their exploits.

Fleeing instability in Europe, a new wave of settlers came to Sheffield in the mid-1800s. Bavarian families purchased tracts of land here and established orchards and vineyards. They created the St. Teresa Church and parish, which continues to flourish today. As the nation divided over the issue of slavery, men from Sheffield, like George Smith who served in both the Army and Navy, went off to fight in the Civil War—26 of them are buried in Sheffield's cemeteries. Our women maintained the homesteads while their men were gone and some, like Maria Root, devoted a year at the Confederate's Andersonville Prison rehabilitating imprisoned Union soldiers that were too weak to return home.

One Sheffield becomes three—

From the beginning the Black River was an important transportation corridor and source of waterpower for early mills, but it also formed a natural barrier that separated Sheffield

into east and west halves. A river ford near present day 31st Street was the only way to cross until the 1880s when narrow steel-frame bridges were built there and at North Ridge—both necessitated a steep climb up the 100-foot high shale bluffs on either side.

In 1894, Tom Johnson purchased a large land holding—about 25 percent of the Township—on the west side of the river to construct a state-of-the-art steel mill and housing for his workers. Part of the arrangement to build the plant on the Black River included the annexation of the mill property by the City of Lorain. At about the same time, the lakeshore east of the river was becoming a popular summer cottage community, many of which were converted to year-round dwellings as economic conditions took a downturn in the 1920s.

Eventually these factors resulted in the Township being divided at the river. The residents on the east side formed the Village of Sheffield Lake in 1920 and those on the west side remained in the Township. Likewise, in 1934 the farmers in the southern part of the new Village recognized they had little in common with the lakeshore cottage community and a second split took place as they formed the Village of Sheffield. By 1960 the population of Sheffield Lake exceeded 5,000, establishing it as a City.

Later as decades passed, each Sheffield evolved into a residential/commercial community composed of numerous subdivisions—thus, many of the past differences have vanished. Now, all three—Sheffield Township, Sheffield Lake, and Sheffield Village—are coming together to celebrate and commemorate the 200th Anniversary of our founding.

During the entire year of 2015 *The Sheffields* will honor their founders and those who followed and strived to make our communities wonderful places to live, learn, work, and raise families.

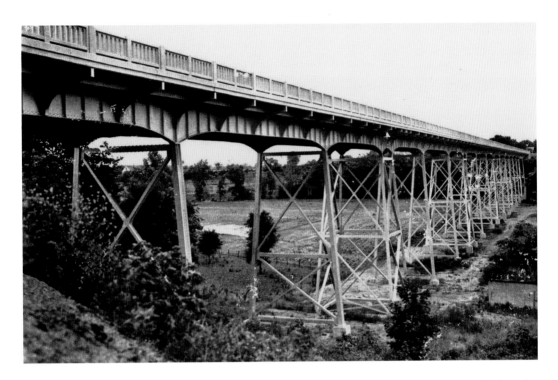

GARFIELD BRIDGE: The original Garfield Bridge over the Black River was built in 1936 on the newly designated State Route 254. Spanning the full width of the valley, the viaduct-style bridge was 1,470 feet long and 90 feet above the riverbed. Eventually the 1936 steel-beamed viaduct succumbed to erosion and metal fatigue. In 2003 the old bridge was dismantled to make way for an elegant concrete-pier bridge carrying four lanes of traffic. The bridge is named in honor of Milton and John Garfield, early settlers of Sheffield.

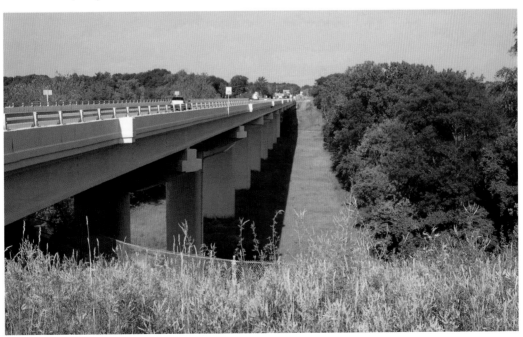

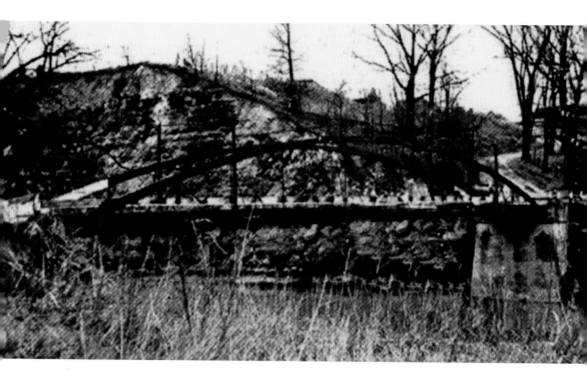

NORTH RIDGE BRIDGE: At what once was a simple ford across the Black River this steel-truss bridge was built in the mid-1800s to connect the east and west halves of Sheffield Township. By the 1930s it had become old and rickety. The steep and perilous climb up the shale bluffs on both sides of the river was also troublesome. In 1936 it was replaced by the viaduct-style Garfield Bridge over the entire valley. Today, just the old abutments are visible from Lorain County Metro Park's bridgeway trail.

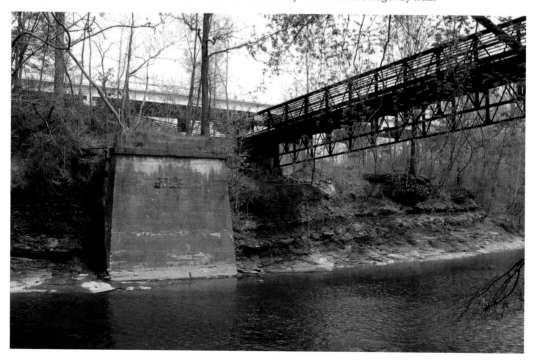

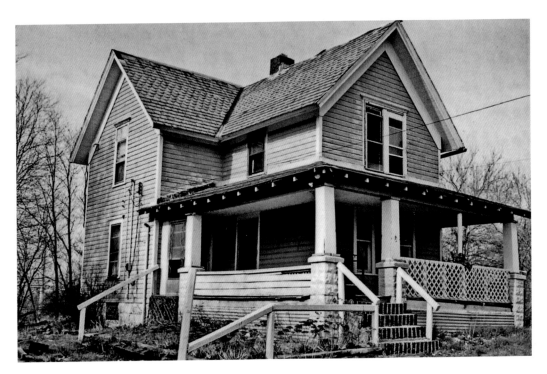

RAYMOND DUNFEE HOUSE: Constructed in 1937 by the Taylor Brothers for Raymond Dunfee, this large, wood-frame, Vernacular-style farmhouse was located near the northeast corner of Detroit and East River Roads. Mr. Dunfee farmed the surrounding land, once owned by original Sheffield settler John Bird Garfield, for many decades before selling the property to the Carter Lumber Company. The house was torn down in 2003.

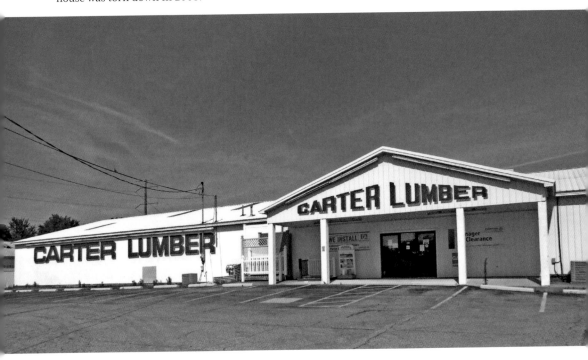

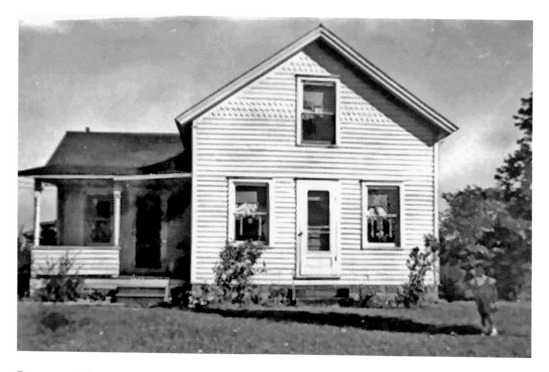

REYNOLDS-HAMMER HOUSE: This small Folk Victorian-style house at 4747 Detroit Road was built *circa* 1870. The house features elaborate trim on the porch supports and scalloped shingles on the front gable. Located on the original North Ridge estate of John Bird Garfield, it was built as a home for his daughter Mary Hulda [Garfield] Reynolds and later for his granddaughter Mabel Edith [Reynolds] Hammer. In recent years it has been converted to the Ye Olde Village Kounty Store specializing in Amish foods, gifts, and furniture.

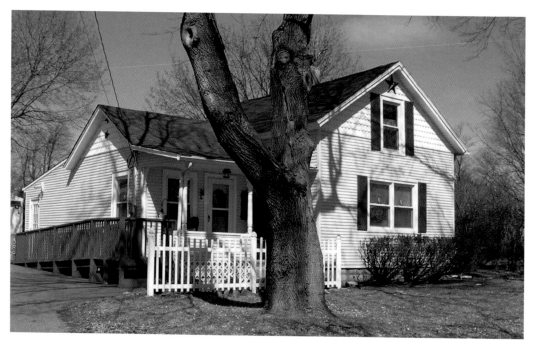

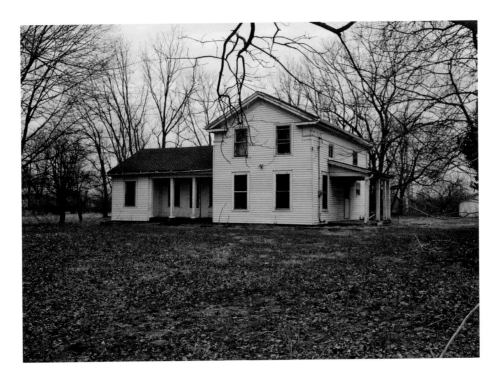

DOUGLAS SMITH HOUSE: Son of War of 1812 veteran Capt. Joshua Smith, 17-year old Douglas traveled overland with his father from Sheffield, Massachusetts to found Sheffield, Ohio in 1815. He married Sarah Burrell in 1824, daughter of Sheffield Township proprietor Capt. Jabez Burrell and built this Greek Revival-style farmhouse in 1833. The oldest surviving building on North Ridge in Sheffield, it now serves as a home and studio for a local artist.

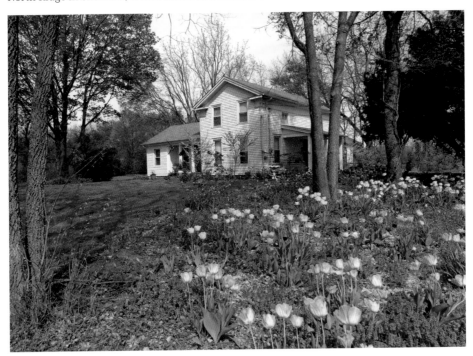

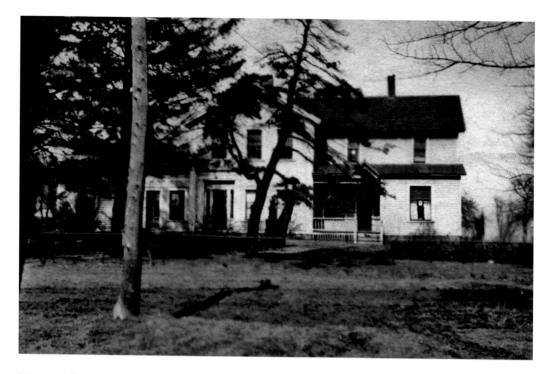

HALSEY GARFIELD HOUSE: When Halsey Garfield and Harriet Root were married in 1855 they contracted with Douglas Smith to build their home on North Ridge. This fine Greek Revival-style house on the Garfield family's homestead is the result of this commission. In the entranceway and windows, Smith added elements of Italianate style, which was just coming into vogue at that time. This house is one of several buildings on the National Register of Historic Places on North Ridge.

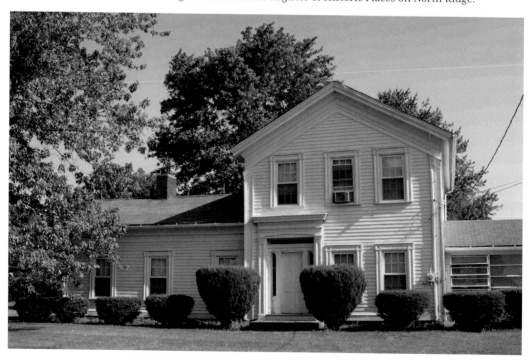

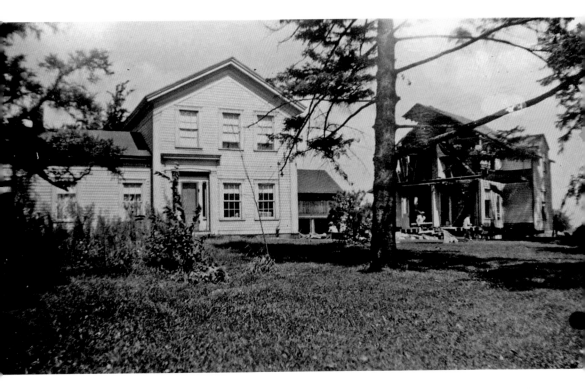

HALSEY GARFIELD HOUSE SPIT: In the late 1930s the Halsey Garfield House was purchased by Michael and Hazel Rath. The old farmhouse proved too large for their needs, and in the early 1940s they decided to split the house into two dwellings. The east wing was severed and moved about a hundred feet in that direction. The former east wing is now known as the Lloyd House.

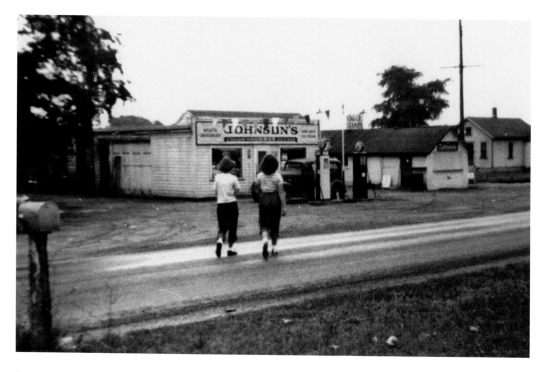

JOHNSON'S GROCERY STORE: Earle and Florence Johnson operated a grocery store and filling station on North Ridge for nearly 30 years starting in the mid-1930s. At the time Johnson's was the only grocery store in Sheffield Village. In the 1950s an ice cream parlor was added as well as a drive-up window for sandwiches and ice cream cones. In the 1960s the store was torn down to accommodate several new homes built on the property.

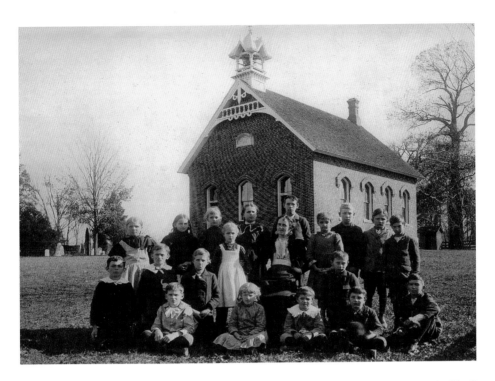

SHEFFIELD VILLAGE HALL: Originally built in 1883 as Sheffield Township District No. 2 Schoolhouse, it is distinguished from typical late-nineteenth-century one-room schools by its elaborate Queen Anne-style wood trim, especially at the peak of the front façade, and the ornate bell cupola. Shown here is the Class of 1911. In 1935 the building was purchased by the newly formed Sheffield Village to serve as its town hall. In 1978 it was placed on the National Register of Historic Places.

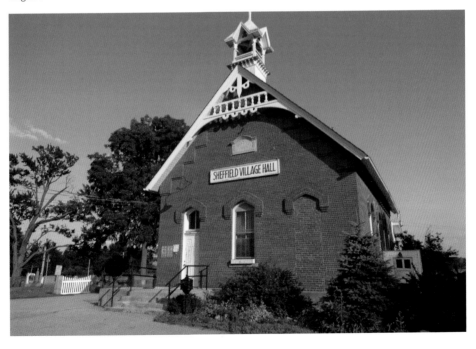

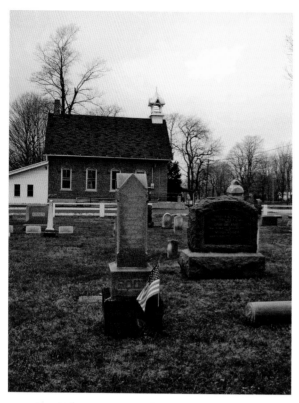

GARFIELD CEMETERY: Established in 1851, this is the oldest cemetery in Sheffield and is still in use. Originally on the homestead of Milton and Tempe Garfield, it was informally used as a graveyard for many years, with some 56 burials having taken place there before 1851. The above monument is for Capt. Aaron Root (1801-1865), a Great Lakes maritime captain and Underground Railroad conductor who was responsible for transporting dozens of runaway slaves on his ships to freedom in Canada.

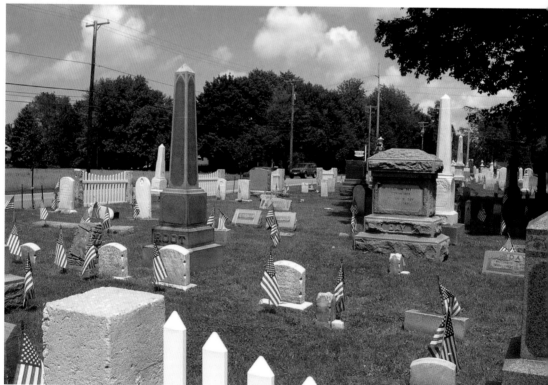

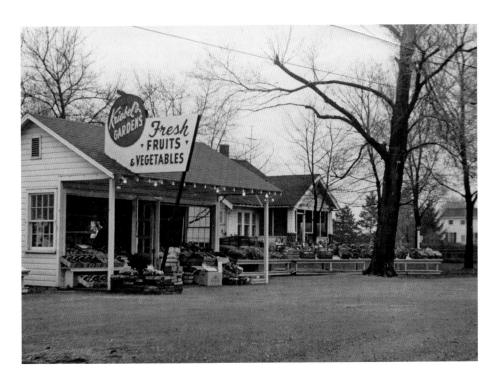

HERBERT KRIEBEL HOUSE: Herbert Peter Kriebel built this Craftsman-style house in 1927 on land purchased from the original Milton Garfield estate. The Kriebel family farmed the land for over 30 years and ran a popular fruit and vegetable stand at the roadside. The property is now owned by Willoway Nurseries, Inc. and farmed by the Demaline family. Members of the Kriebel family continue to live nearby.

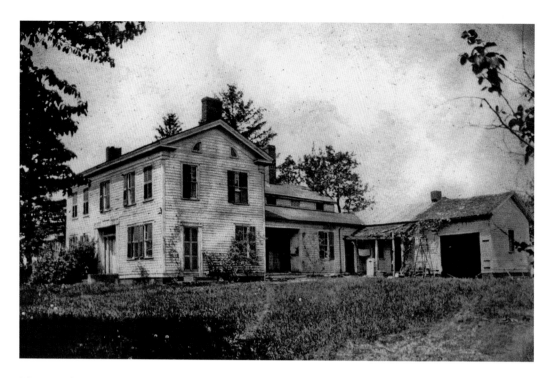

MILTON GARFIELD HOUSE: Ezra Jackson built this classic Greek Revival-style farmhouse for Col. Milton Garfield in 1839. Garfield was the original settler of Sheffield's North Ridge in 1815. The ridge is the remnant sand beach of glacial Lake Warren that occupied the area some 13,000 years ago. As a young man, Milton walked from Tyringham, Massachusetts to Ohio carrying his rifle and an axe. The current owners are the fifth generation of the Garfield family to live in this house.

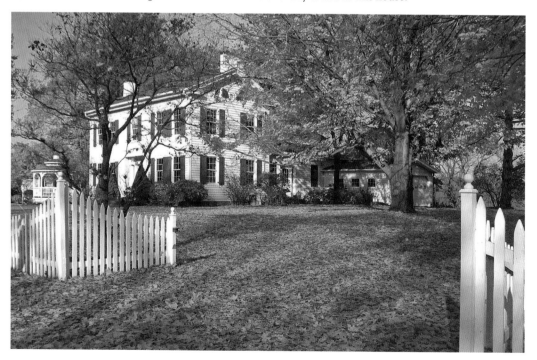

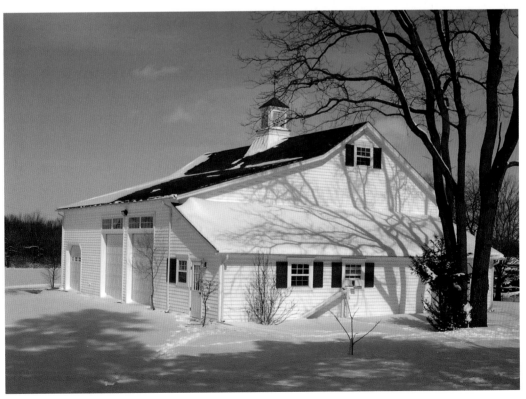

GARFIELD FARMS BARN: Ada Rider Root, wife of Henry Garfield Root, climbs onto a wagon in front of the twin barns owned by her husband and her brother-in-law, George Williams Root. In October 1918, lightning stuck George's barn and quickly spread to the other. Both barns burned to the ground, taking with them a carriage horse that could not be persuaded to leave the burning building. Nine decades later, Henry's grandson researched the old structure and rebuilt a replica on the Garfield homestead.

HENRY GARFIELD ROOT BANK BARN: Milton Garfield's grandson, Henry Root, built this small bank barn in 1918 to stable farm horses and a cow. Originally a temporary replacement for his burned barn, it still stands. The wall studs are 4-by-4 inch chestnut posts and the floor beams still have bark. The old SOHIO (Standard Oil of Ohio) 300-gallon gasoline tank was serviced by fuel-delivery companies in the 1950s.

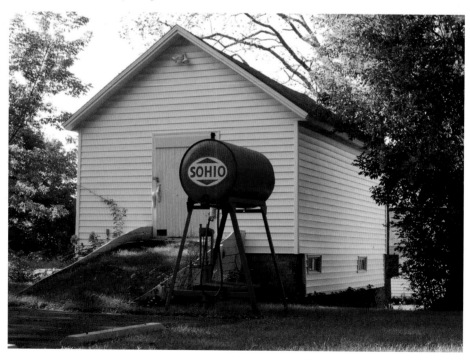

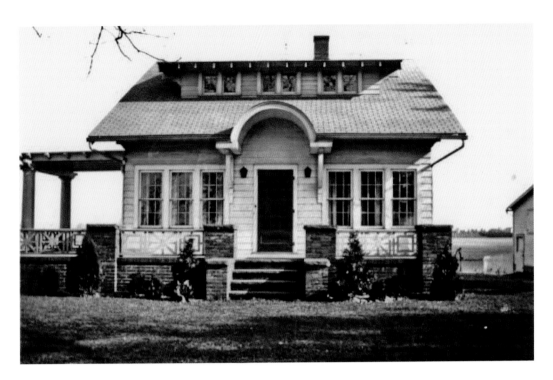

CLYDE MCALLISTER HOUSE: Clyde McAllister built this Craftsman/Bungalow-style farmhouse on North Ridge in 1929. The house features an unusual semi-circular roof over the main entranceway that is supported by curved brackets. When the Village of Sheffield was formed in 1934, Clyde was elected its first mayor. He is credited with undertaking the daunting task of creating a new community that grew and prospered. The blue building to the right was once the McAllister barn.

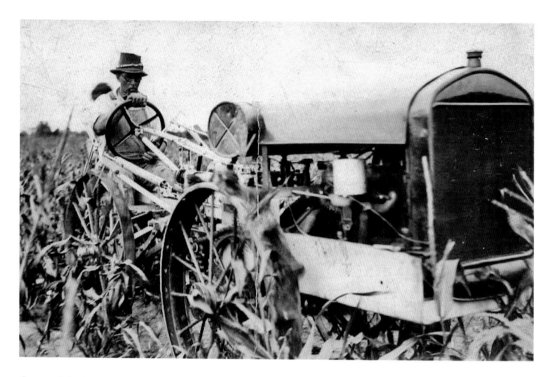

CLYDE MCALLISTER FARM: Clyde McAllister was born in 1885 at Millport, Columbiana County, Ohio and moved to Lorain County with his parents in 1895. In 1929 he and his wife Louise purchased farmland on North Ridge in Sheffield and built the home they lived in for 25 years. In 2007 much of his former farmland was purchased by the Mike Bass family and a Mazda automobile dealership was constructed on the property.

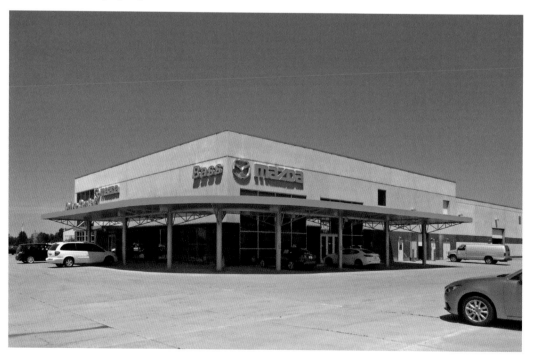

DANIEL GARFIELD BARN: Daniel Garfield was the third son of Milton and Tempe Garfield. After his father's death he farmed the family homestead and soon after the Civil War ended he built a home and a large bank barn on the eastern edge of the farm. The barn survived for 140 years, until that portion of the original homestead was purchased to construct an automobile dealership. Fortunately the barn was systematically dismantled and reconstructed two and a half miles away on French Creek Road.

SHEFFIELD HISTORY CENTER: This Colonial Revival-style house had its beginning as a small Vernacular-style farmhouse built by George Williams Root in 1914. It was acquired by Walter McAllister in 1937 and virtually expanded in every direction. Walter, the son of Clyde McAllister, served as Sheffield Village's first fire chief, a councilman, and its fourth mayor. The house now serves as the Sheffield History Center—the headquarters, archives, and museum of the Sheffield Village Historical Society.

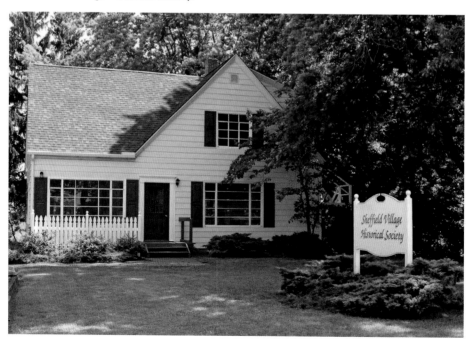

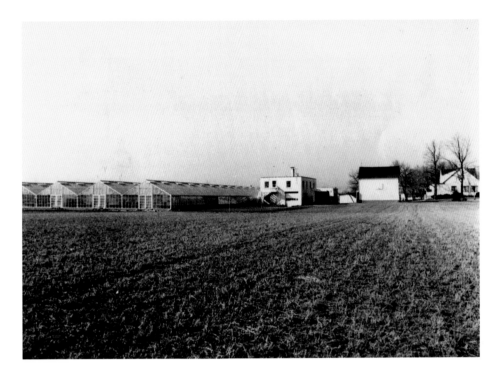

McAllister Greenhouses: Walter McAllister was one of the first farmers to construct greenhouses on North Ridge soon after the end of World War II. The sandy soil of North Ridge proved ideal for growing greenhouse tomatoes and gourmet cucumbers. By the late 1970s, some 20 North Ridge farmers had 45 acres under glass. Environmental regulations and the availability of Mexican-grown tomatoes lead to the demise of the greenhouses and now the former McAllister land is occupied by an automobile dealership.

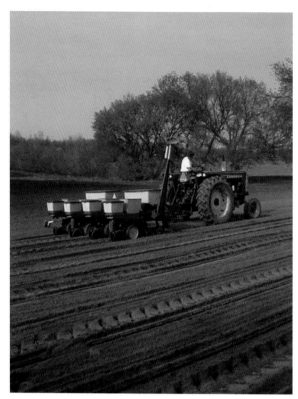

EMH SHEFFIELD MEDICAL BUILDING: The fertile, sandy soils of North Ridge attracted many New England farmers to Sheffield. For nearly 200 years the land has supported dozens of farm families. The ridge formed a natural roadway, which has become a major transportation corridor. In recent decades commercial establishments have replaced many of the farms. One of the most recent is the EMH (Elyria Memorial Hospital) Medical Building, built in 2007.

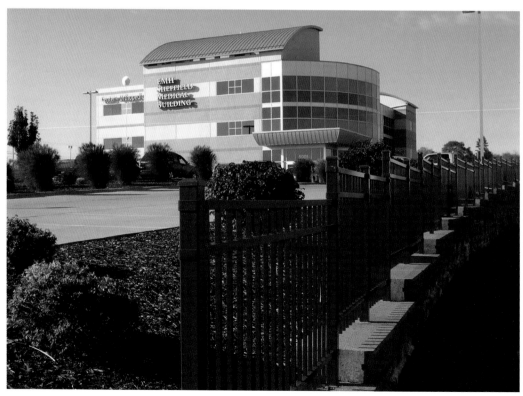

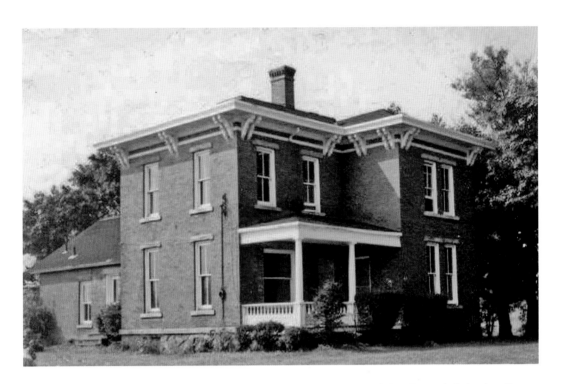

GEORGE MOON HOUSE: Built in 1855, this Italianate-style brick farmhouse belonged to George Moon, son of Oliver Moon—one of Sheffield's pioneers. The farm, located on North Ridge, once had slaughterhouses and a butter factory. The front porch supported by Doric columns was added in 1875. Victor and Rosella Gubeno Gornall were owners of the house in 1976 when the Lorain Historical Society awarded them a Century Home plaque. In 1990 the house was demolished to make room for fast-food restaurants.

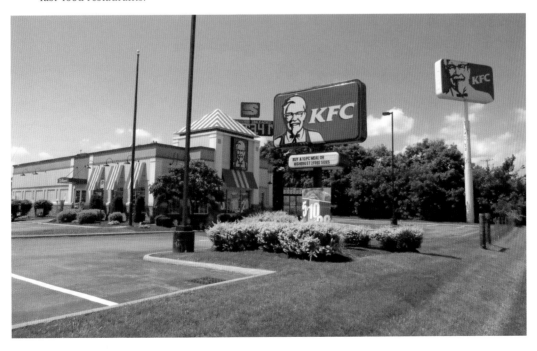

ABBE ROAD APPROACH: The above photograph was taken in 1966 along North Ridge (State Route 254) about 500 feet west of the Abbe Road intersection. Much of North Ridge then was farmland. The image below demonstrates the commercial development that has taken place along the same stretch of North Ridge in the nearly five decades since the first photograph was taken. Abbe Road is now designated as State Route 301.

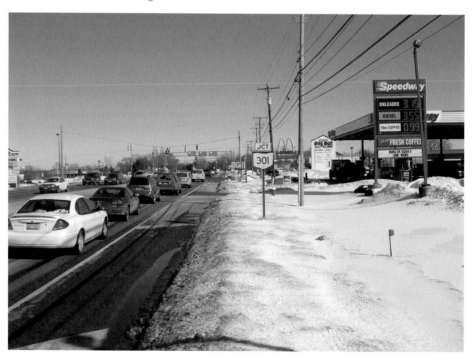

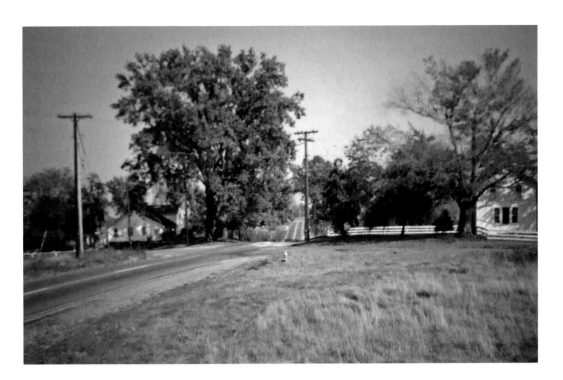

DETROIT AND ABBE ROADS INTERSECTION: The above photograph was taken at the intersection of Detroit Road (State Route 254) and Abbe Road (now State Route 301) in 1966. The countryside is open farmland with two farm houses at the intersection. The lower image, nearly 50 years later shows that the farmland has been replaced by Sheffield Crossing—a commercial shopping center.

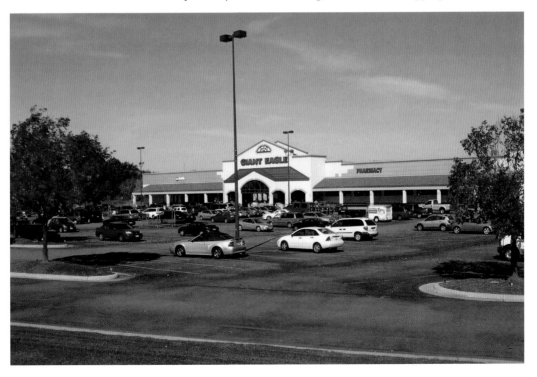

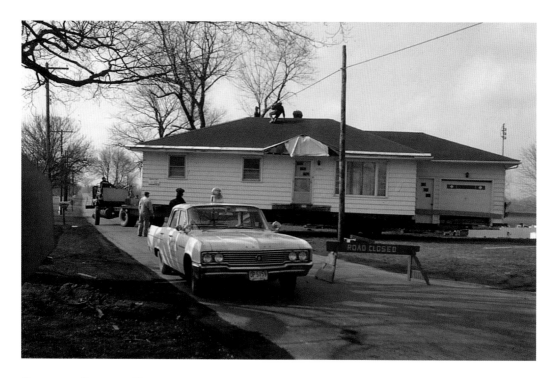

CHARLES GUBENO HOUSE: As commercial developments replaced farmhouses along North Ridge, many of the older homes were either torn down or moved. Above, the Charles Gubano house is being moved south on Abbe Road to a new, albeit temporary, location as development progressed in that direction. The southwest intersection of Abbe and Detroit Roads, where the Gubeno House once stood, is now the location of the Sheffield Branch of KeyBank.

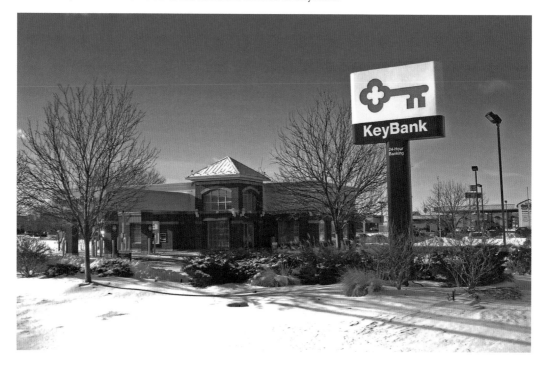

JOHN TOWNSHEND HOUSE: In the 1870s John Townshend built a Vernacular-style wood frame farmhouse on the southeast corner of Abbe and Detroit Roads. Like many of the farmhouses on North Ridge, the Townshend house was torn down in the 1960s to widen the intersection and to make way for commercial development. A Sears, Roebuck & Co. hardware store is now located on the former site of the Townshend homestead.

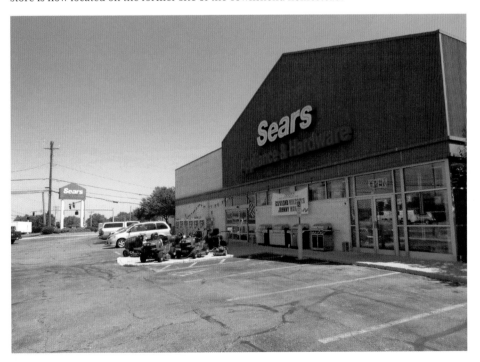

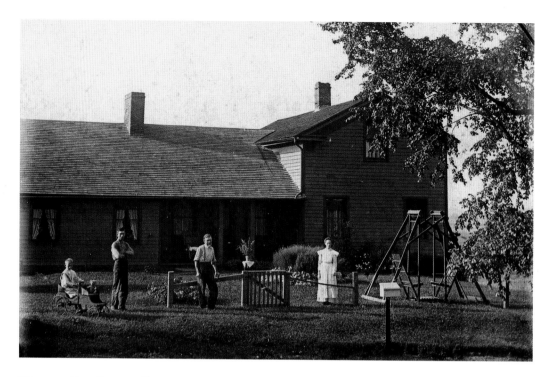

WARDEN-FOX-BROWN HOUSE: In the 1830s John Warden, emigrated from England and purchased 35 acres of land at the north east corner of Abbe and Detroit Roads. Here he built a Greek Revival-style farmhouse. In 1882, the James Fox family (pictured above in 1913) acquired the house and lived there for 40 years. In 1922, Edward Brewster Brown purchased the house (pictured below in 1964) where he and his wife Leona raised their family of four daughters and one son.

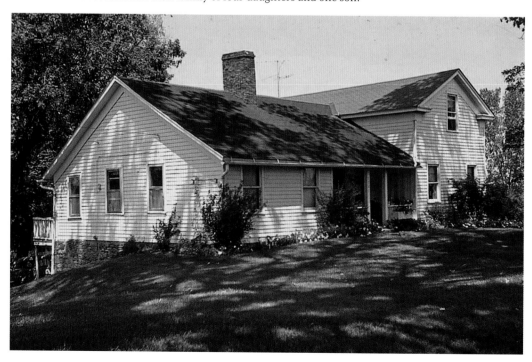

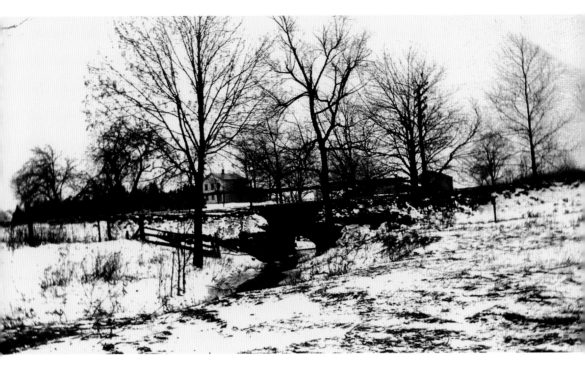

SUGAR CREEK: A small stream known as Sugar Creek once flowed through a culvert under North Ridge when the Edward Brown family lived at the northeast corner of Abbe and Detroit Roads. In 1966 the Brown House was burned down to accommodate the widening of Detroit Road. In 2010 several hundred feet of the stream were encased in a tunnel that now runs under the gas pumps and parking lot of a Sheetz service station.

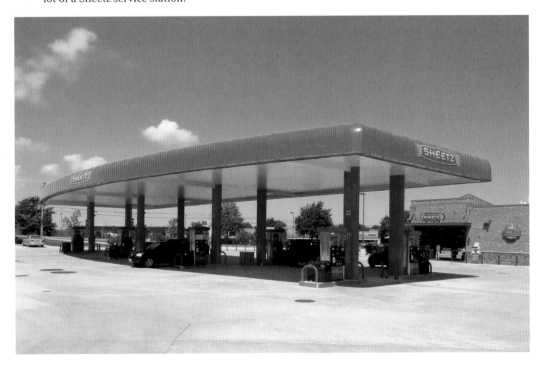

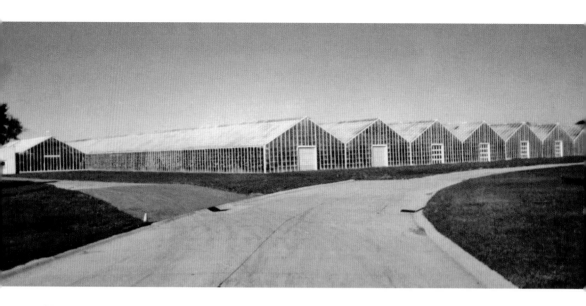

HILTABIDDLE GREENHOUSES: Robert and Marylou Hoag Hiltabiddle operated a large greenhouse assembly of nearly two acres on North Ridge east of Abbe Road from 1958 until 1995. Initial production was "hothouse" tomatoes and cucumbers, but as this market dwindled, flowers became more profitable. In the mid-1990s the greenhouses were demolished and the land was acquired for development as commercial offices and residential apartments, under the Waterford name.

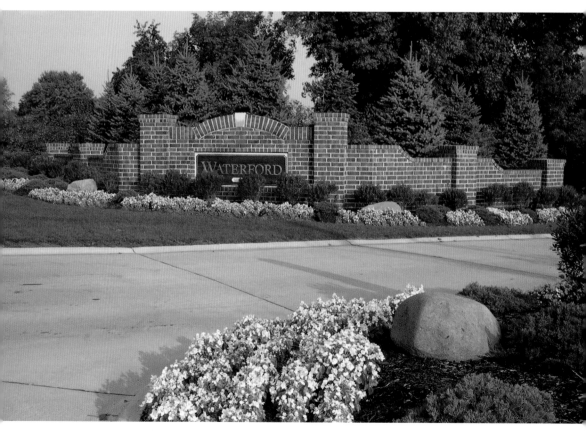

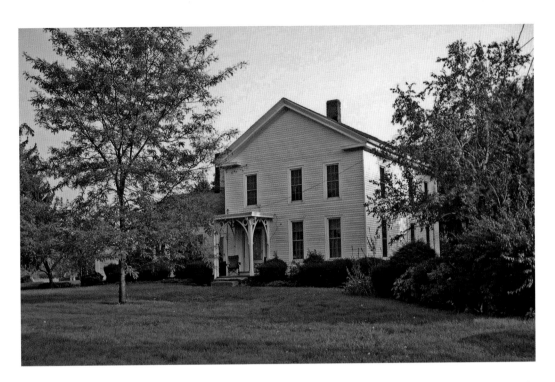

TOWNSHEND-DECHANT HOUSE: Joseph Townshend built this wood-frame Greek Revival-style house with an Italianate-style front porch in 1855. The basic proportions of the house, its bold simple cornice, and the main entranceway with sidelights and transom are typical Greek Revival features. The house and the 72-acre farm was acquired by Andrew and Clara Mackert in 1910. Their daughter Alice married Charles DeChant in 1935 and they raised their four children in the house.

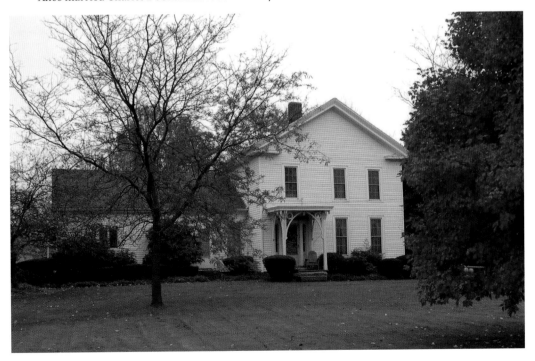

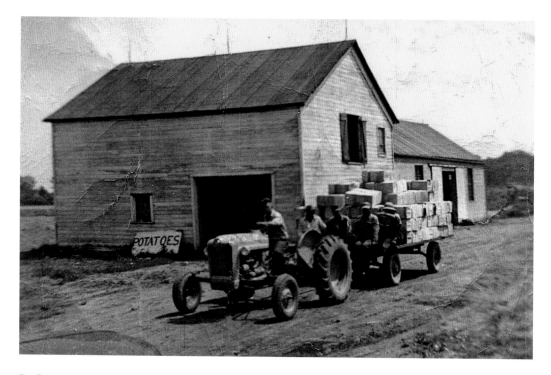

DeChant Farm: For over 60 years Charles DeChant and his children farmed the land, first as a truck farm supplying produce to the Cleveland and Pittsburgh markets. In 1954 greenhouses were constructed on three and a half acres of the farm. In the 1990s the family undertook the Village Reserve housing and business development project on the northern portion of the farm and the Wesleyan Meadows retirement community on the southern portion.

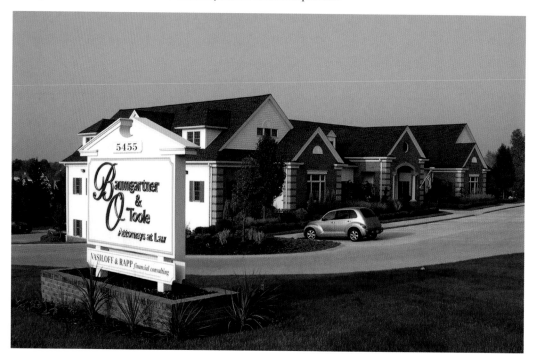

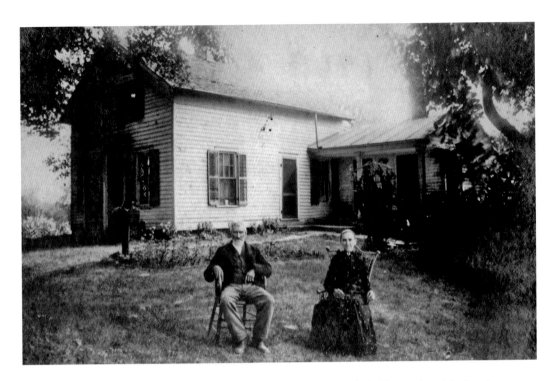

NATHANIEL DUNFEE HOUSE: Nathaniel and Sarah's Dunfee's Vernacular-style farmhouse was located on North Ridge in Sheffield Township, a short distance west of the Black River. They farmed the land on the ridge for 45 years and raised four daughters and four sons. Nathaniel was born on the Lake Erie shore at Angola, New York and died in his Sheffield house at age 74. In the 1990s the homestead was torn down to make way for regional offices of the Columbia Gas Company.

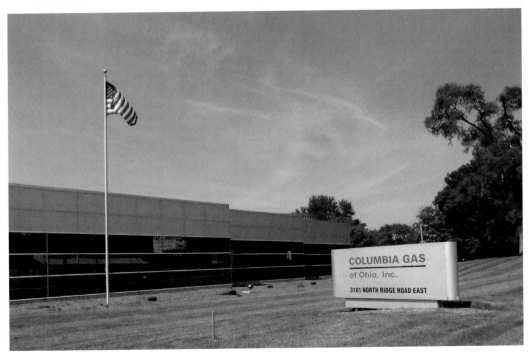

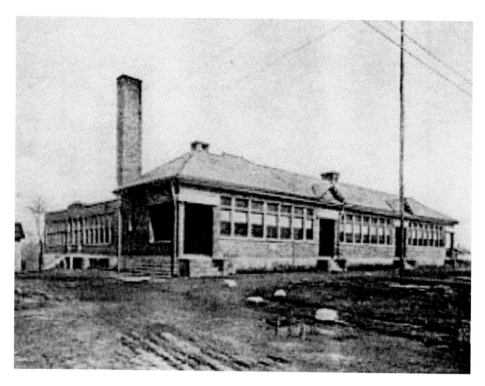

VINCENT SCHOOL: A small one-room school, Sheffield Township District No. 6 Schoolhouse, was located on North Ridge Road in the 1870s. In the 1920s it was replaced by a multi-room school at Vincent, also known as Stop No. 7 in reference to the "Yellow Line" trolley stop at this location. In recent years the Vincent Elementary School has been modernized and enlarged.

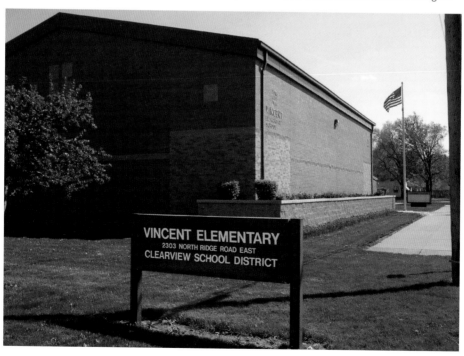

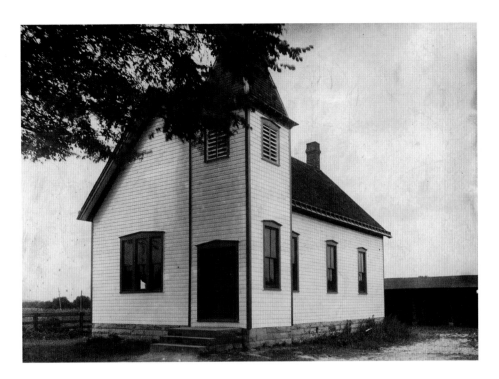

VINCENT METHODIST CHURCH: This Queen Anne/Vernacular-style country church was constructed in 1910 a short distance east of Stop No. 7 on the "Yellow Line" trolley streetcar tracks that provided service between Lorain and Elyria. Horse sheds can be seen behind the church in the upper view. The Vincent Methodist Church was reformed as the Cornerstone United Methodist Church and moved to West River Road in Elyria. The old building is now utilized as the Faith House Day Care Center.

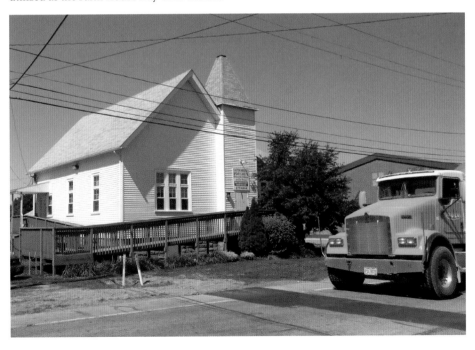

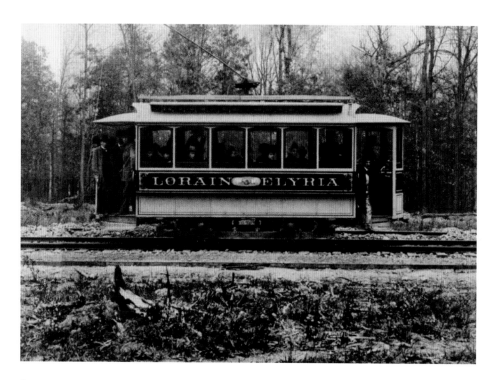

LORAIN-ELYRIA TROLLEY: Interurban trolley cars started operating in 1894 between Lorain and Elyria, Ohio on Tom Johnson's "Yellow Line" electric railway. The Line was built to transport workers to his new steel mill on the Black River. The line was disbanded in the late 1930s and in the 1950s State Route 57 was constructed along the old right-of-way. Oakwood Park was established by Tom Johnson along the trolley route near the steel mill.

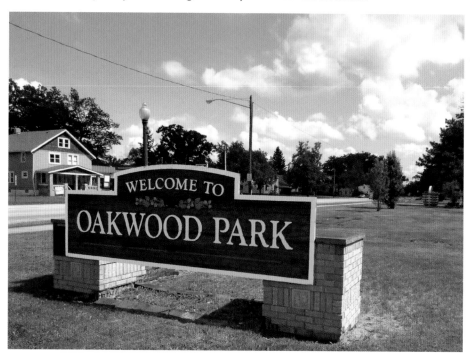

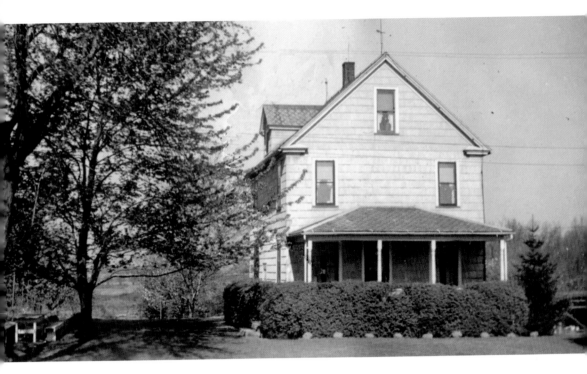

COTTON HOUSE: Elmer Cotton built this 1890s wood-frame farmhouse for his elderly parents Newton and Caroline Cotton. After his parents died, Elmer gave the house to his son Leon as a wedding gift. When the house was damaged in the Lorain tornado of June 1924, the wood siding was replaced with asbestos cladding. In 1962 the house was purchased by Frank Martin who sealed and covered the façade with 190 tons of sandstone from the Amherst quarries.

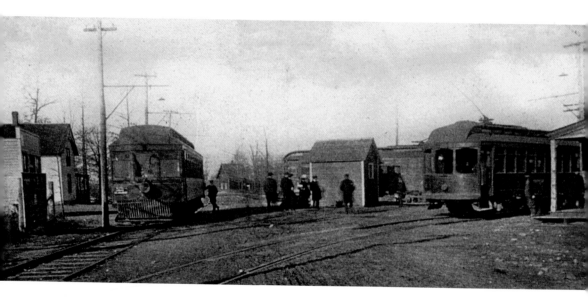

PENFIELD JUNCTION: The Cleveland, Southwestern & Columbus Railway, known as the "Green Line," provided interurban trolley service between Lorain, Elyria, and Amherst from 1895 to 1931. Because the cars blended into the fields and forest through which they sped, in 1927 the fleet was painted orange to reduce accidents. Penfield Junction, the intersection of service to these three communities, was located in Sheffield Township near Clearview High School. Today the junction is represented by the intersection of Broadway and North Ridge Road.

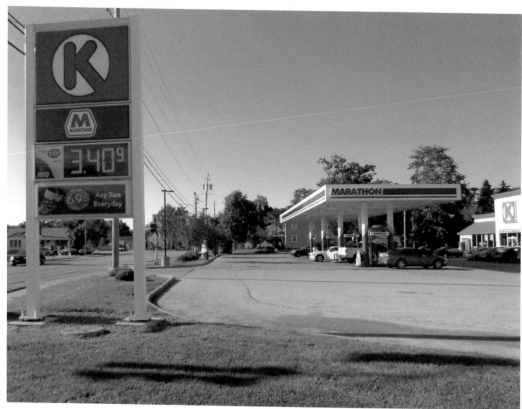

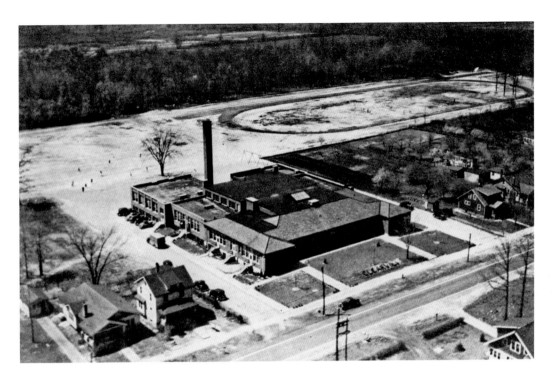

CLEARVIEW HIGH SCHOOL: Built in 1923 as Highland School, it was part of the Sheffield Lake School District serving grades one through eight. In 1930 the name was changed to Clearview to reflect the new school district. A year later Clearview was approved for 12 grades and graduated its first class of 11 seniors. The above aerial view shows the school in 1936. Several additions have been added through the years with the latest one being completed in 2004.

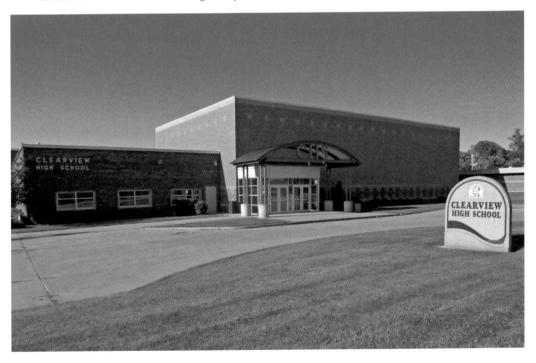

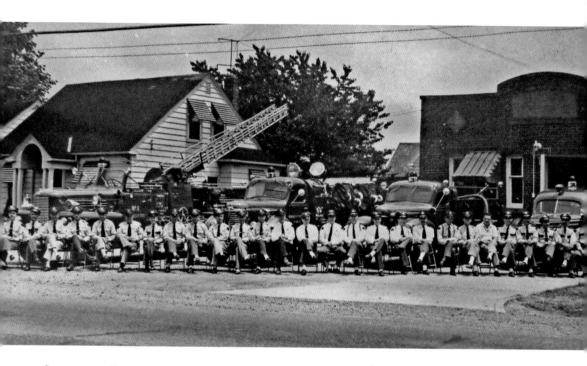

SHEFFIELD TOWNSHIP FIRE DEPARTMENT: The Sheffield Fire Company was organized in 1931 and headquartered in a small, brick station house located on Broadway until the new Sheffield Township Engine House No. 1 was completed in 2010. The new station is located in the western part of the community, farther south on Broadway. A second firehouse, Station No. 2, is located on the township's east side at Clinton Avenue. The Fire Department is made up of volunteers who live throughout the township.

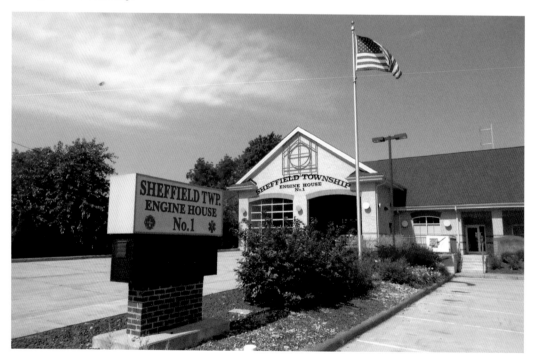

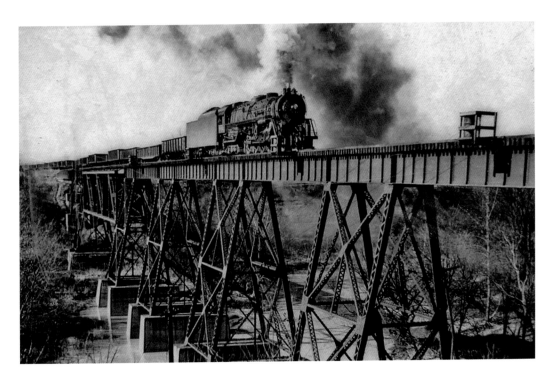

LORAIN & WEST VIRGINIA RAILROAD TRESTLE: Crossing the Black River valley just upstream of the Garfield Bridge (State Route 254), the trestle was constructed in 1906. The above view shows a steam locomotive in 1934 carrying coal from the Ohio valley to the National Tube Company's steel mill in Lorain. A subsidiary of the Wheeling and Lake Erie Railway, the L&WV RR operated a 25-mile spur from Wellington. The line was abandoned in the 1960s, but the rusting trestle remains standing.

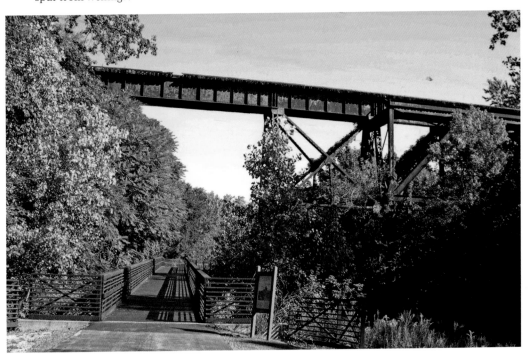

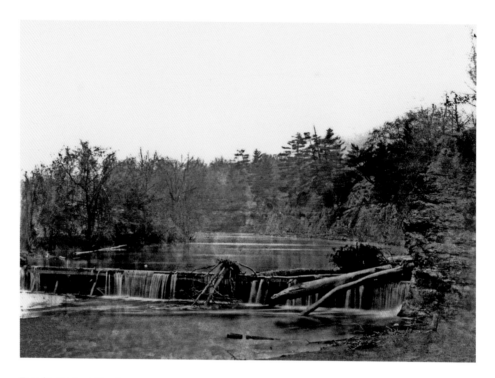

DAY'S DAM: The dam was constructed on the Black River by John Day in the early 1800s to provide a constant head of water for a sawmill and gristmill located downstream. A requirement for proprietors of townships in the Connecticut Western Reserve was that they provide such mills for the settlers. The dam was dynamited in the early 1900s to allow more fish to move upstream. Only a low rapids in the river remains where the dam once stood.

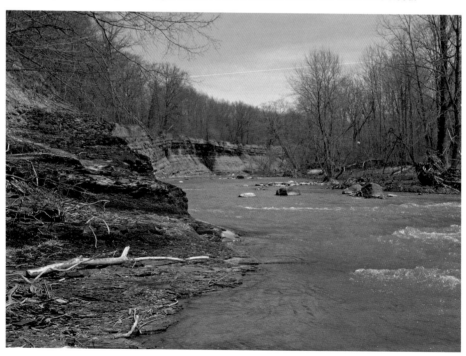

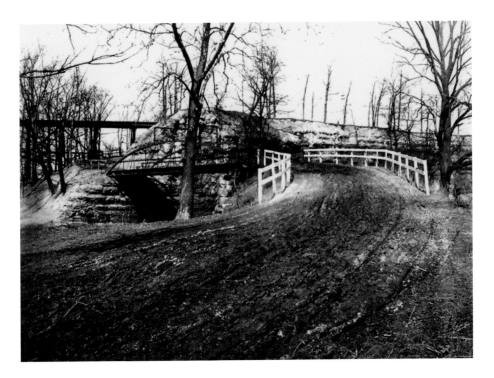

DAY'S DAM BRIDGE: One the first bridges to cross the Black River in Sheffield was this iron-trussed structure built in the 1880s near Day's Dam, hence the name of the bridge. The southern approach road was unpaved and a steep hill had to be negotiated at the northern approach. The bridge was torn down when the 31st Street bridge was completed in 1913. Today only the massive sandstone abutments remain.

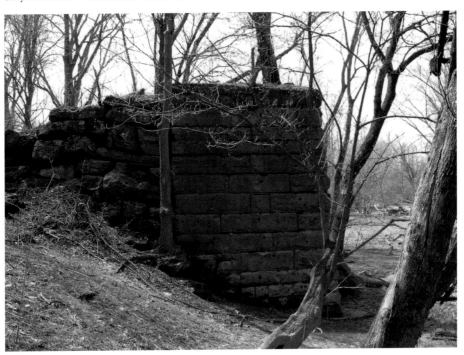

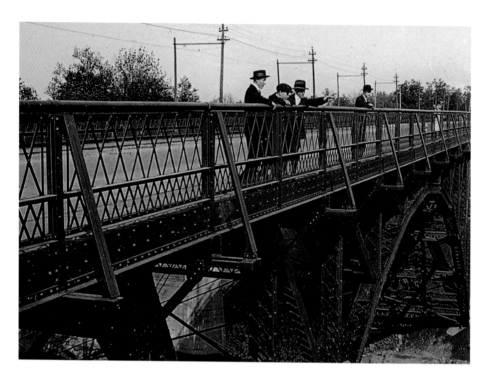

31ST STREET BRIDGE: The high-level bridge over the Black River at 31st Street was constructed by the Pittsburgh Bridge Company in 1913 at a cost of $62,000. Unlike the Garfield Bridge of two decades later, which had a viaduct spanning the entire valley, the 31st Street Bridge was shortened by building an 800-foot causeway. The 370-foot remaining ravine was bridged with a series of graceful arches. A modern concrete pillar bridge now spans the river.

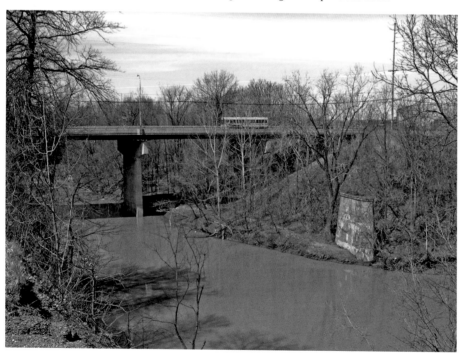

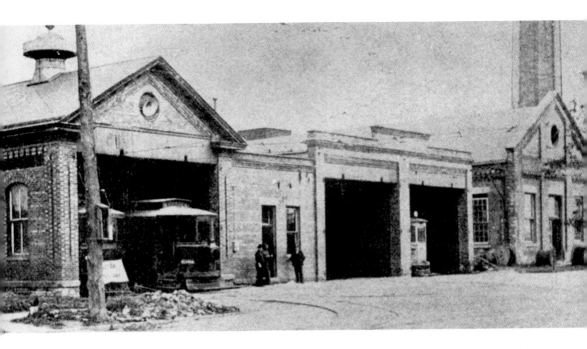

STREETCAR BARNS: The Lorain Street Railway's streetcar barns (left) and power plant (right) were built by Tom Johnson in 1894 on 10th Avenue [now 28th Street] at the foot of Seneca Avenue. Located adjacent to his steel mills, streetcars were serviced in the barns and the coal-fired power plant supplied electricity to run them. The notches above the door openings were to accommodate the trolleys. These facilities are still standing, but idle.

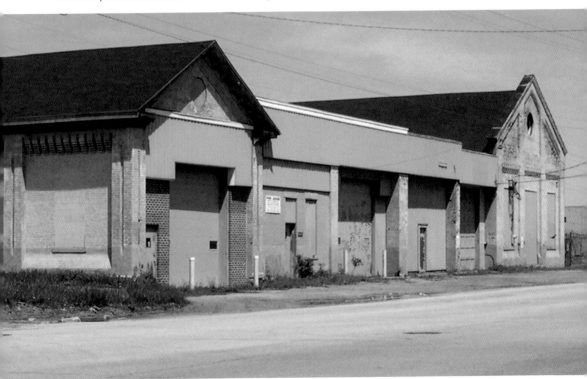

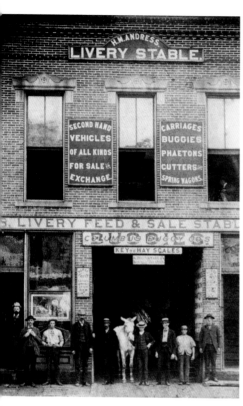

LIVERY STABLE: The H. M. Andress Livery Stable at the Corner of Pearl Street and 10th Avenue [now 28th Street], South Lorain, *circa* 1895. Originally within Sheffield Township, Lorain annexed a large tract of township land (4,000 acres) in 1894 as part of an arrangement to induce the Johnson Steel Company to build its mills on the west side of the Black River. A modern branch bank building now stands on the land where the livery stable was once located.

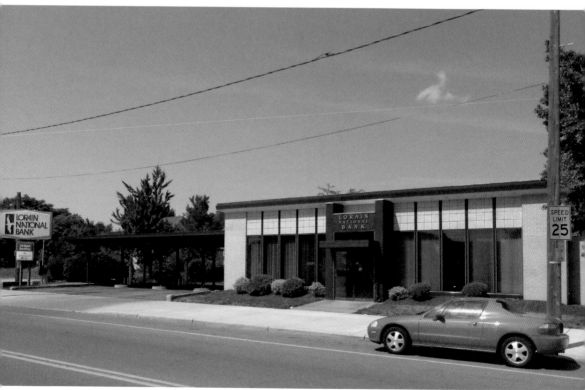

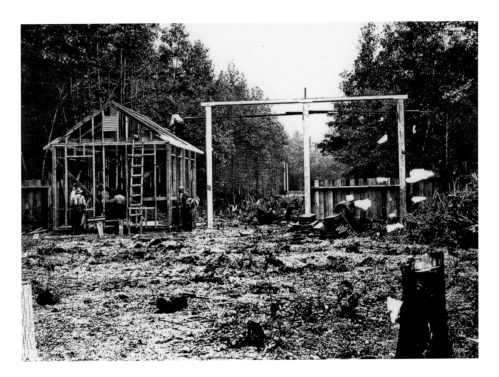

JOHNSON STEEL COMPANY OFFICE BUILDING: The above view of the James Day farm in May 1894 shows a portion of the 4,000 acres purchased in Sheffield Township by the Johnson Steel Company for the construction of new mills on the west bank of the Black River. The lower view is of the steel mill's office building erected shortly after, 1895, and now serves as the headquarters for Republic Steel Corporation's Lorain mills. This building is on the National Register of Historic Places.

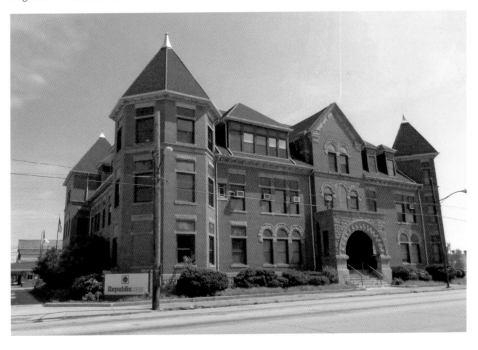

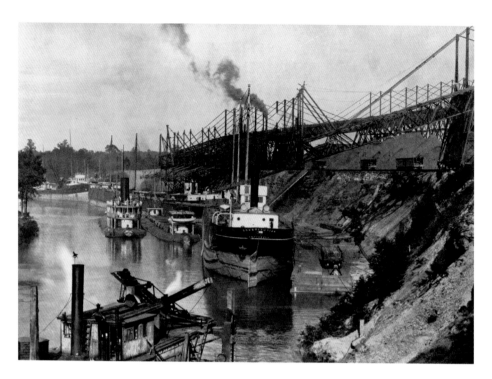

STEEL MILL DOCKS: The upper view is of the National Tube Company's ore docks on the Black River in 1899. Rail-mounted McMyler hoists are transferring iron ore from lake freighters to a storage yard at the mills. Vessels include the steam barge *Constitution* (large vessel ahead of the foreground steam dredge) and two whaleback boats. Today the river is still used by bulk cargo vessels. Below, the *Joseph H. Thompson* self-unloads stone at a riverside dock.

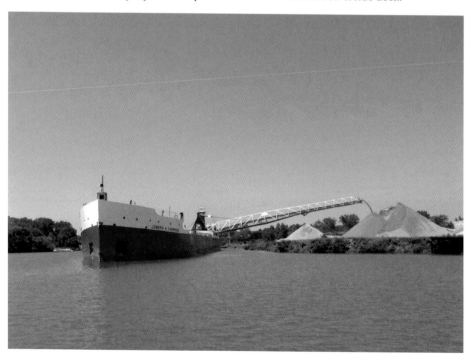

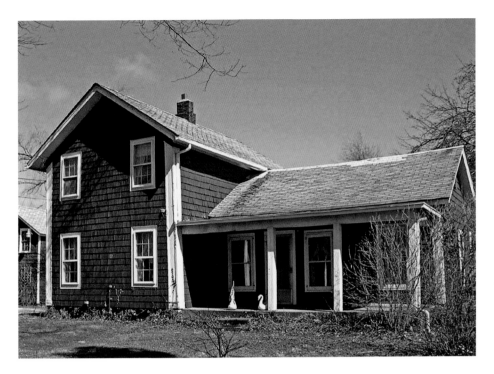

SMITH-KINNEY-ROOT HOUSE: Douglas Smith and his son Perry built this Classical Revival-style farmhouse in 1857 on East River Road. Unusual for the area, it is serviced by a semi-circular driveway. Judson Kinney acquired the farm in 1869 and sold it to a steel company in 1917 in anticipation of a new mill, which never materialized. In 1944 Henry Garfield Root and his wife, Ada Rider Root, bought the farm and lived there for 30 years. Their descendants still own the property.

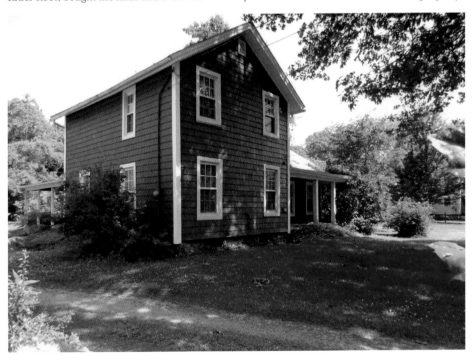

ROOT FARM GRANARY: Douglas Smith also constructed a large hay barn and a granary adjacent to the 1857 farmhouse. The hay barn was moved a quarter mile north to the Gerber farm in 1948 and the granary was lowered and reconfigured as a garage by Henry Garfield Root. He later added a lean-to garage, which now houses the 1946 Sheffield Village fire truck that has been restored by the Sheffield Village Historical Society.

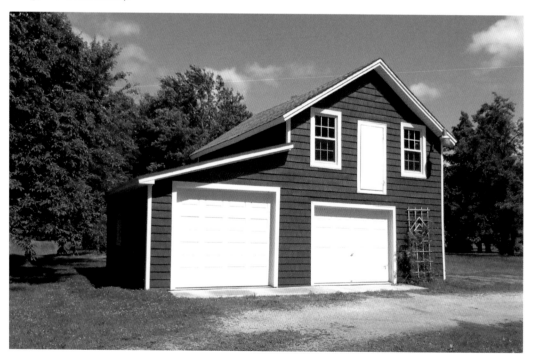

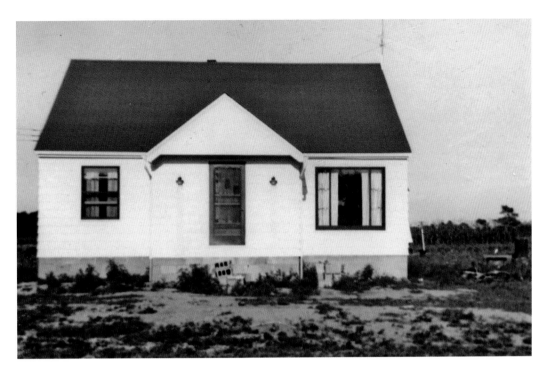

EDWARD HERDENDORF HOUSE: In 1948, Henry Garfield Root offered an acre of land to his daughter Kathryne and son-in-law Edward Herdendorf if they would build their home on the property. The house was completed in 1949. In 1952 the Herdendorfs started what would become an 800-tree peach orchard on this property and two additional acres. Edward served as Sheffield Village Fire Chief in the 1950s and early 1960s. Mark Charlton, the current owner, has extensively modernized the home.

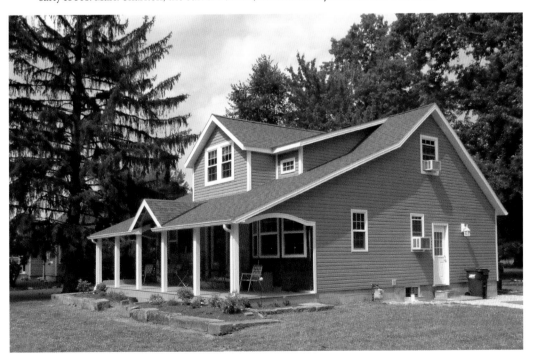

FERGUSON FARMSTEAD: In 1920, the Farm Realty Company initiated the first real estate development in Sheffield, known as Farm Acres, by acquiring a 108-acre tract of land on East River Road. The tract was divided into several-acre plots, and dedicated avenues were laid out. The Ferguson farmstead, on Walnut Avenue, was the first to be built as a complete small-scale farm with livestock, poultry, and vegetable crops. Over the years the original house been enlarged with a massive dormer and a rear extension.

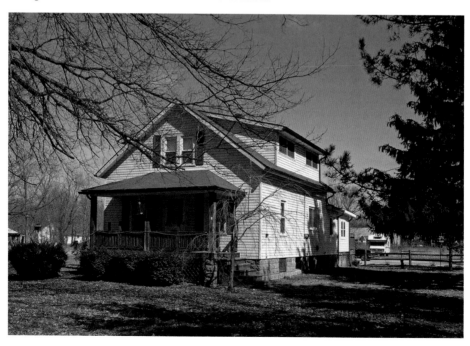

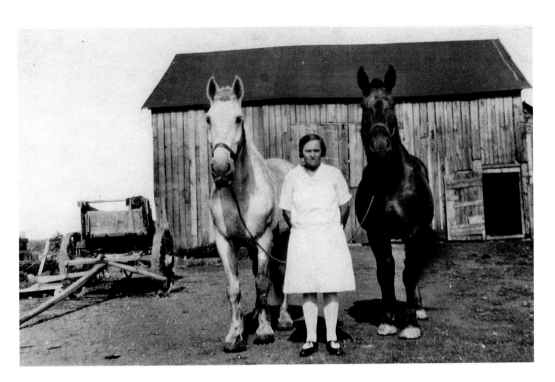

GERBER-CUNNINGHAM-TERNES FARM: This family farm is located on East River Road near the eastern bluff of the Black River. The above photograph shows Lydia Gerber Cunningham holding the reins of her farm horses in the 1930s. Members of this family, such as Rick Ternes (left, Lydia's great grandson) and his father Tim, still raise horses and are active exhibitors of their livestock and historic tractors at the Lorain County fair in Wellington.

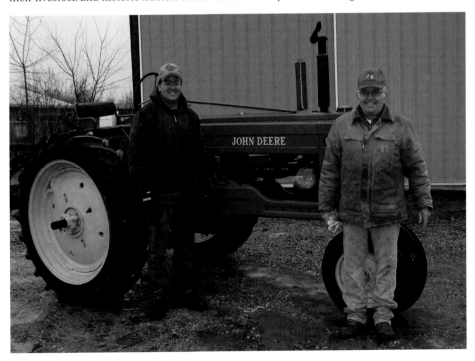

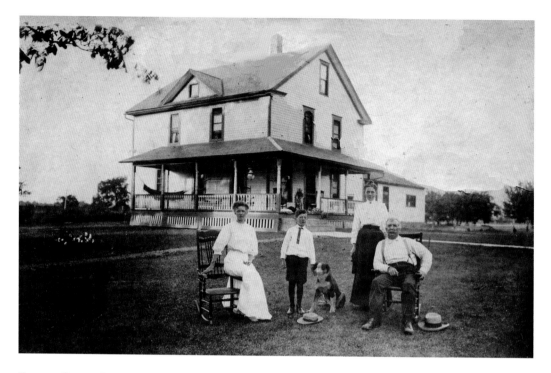

FRANK CALEY HOMESTEAD: Built in the mid-1800s, the large Greek Revival-style farmhouse was the home of Frank Caley and several generations of the Caley family to this day. The house looks much the same today as it did in the above late 1906 view. The Caley family migrated to America in the early 1800s from the Isle of Man, a small island in the Irish Sea between England and Ireland.

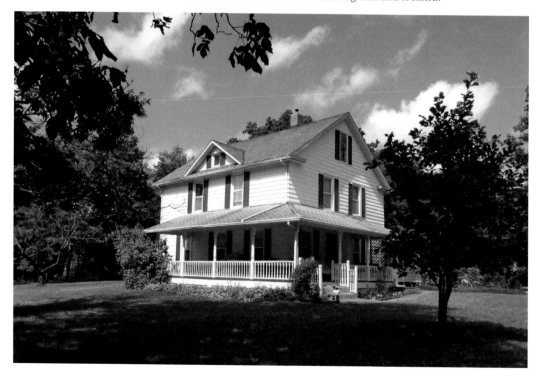

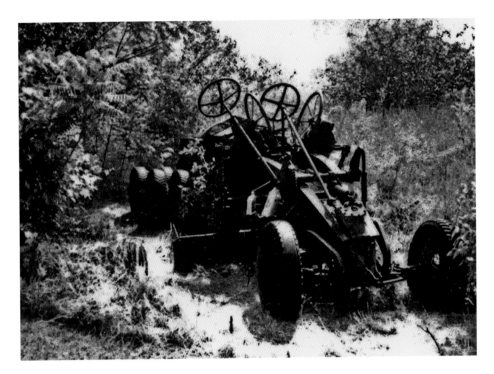

SHEFFIELD'S FIRST ROAD GRADER: In the early days of Sheffield Village, before paved roads, this grader was used to smooth the road surfaces. The machine was a McCormick-Deering Warco one-man grader fabricated in 1928. The grader had four steering wheels—one to operate a scarifier used to break up the ground, two for controlling the depth and position of the scraper blade, and a center wheel for steering. The grader was found rusting on the Caley farm and restored by Frank Root.

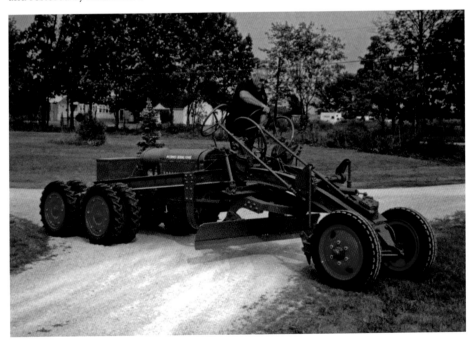

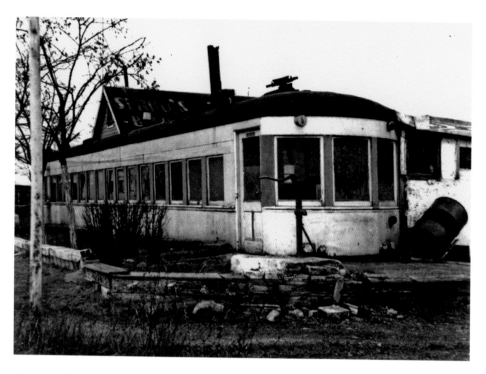

FRENCH CREEK HOUSE: Once a service station, this small Victorian Shingle-style house at the intersection of French Creek and East River Roads was built *circa* 1890. The building features fishscale-style shingles on the porch and front gables. This building may also have been Serbu's Traven in the late 1930s as shown in the upper view. The retired interurban trolley car found new service as a diner.

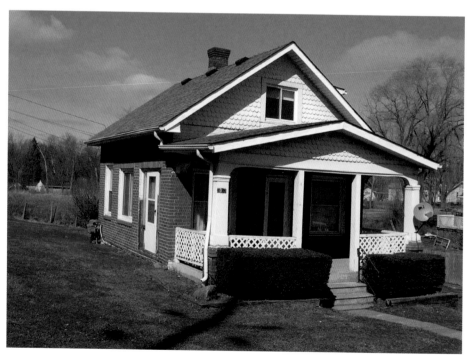

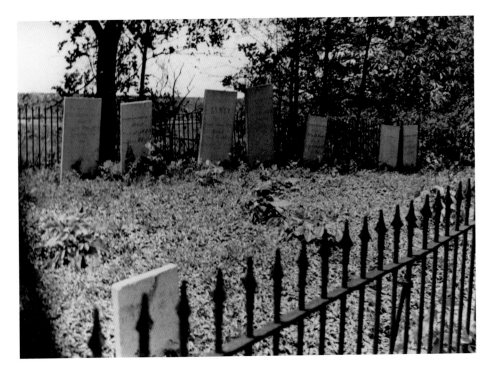

PIONEER CEMETERY: Only 15 burials have taken place in this tiny cemetery, but it contains the remains of two of Sheffield's founding families—the Days and Roots. Capt. John Day and wife Lydia Austin Day and Henry Root and wife Mary Day Root (sister of John Day), who arrived in Sheffield in 1816, are interred here. Pioneer Cemetery was established in 1825, only ten years after Sheffield was founded. The cemetery is maintained by the Village of Sheffield Service Department.

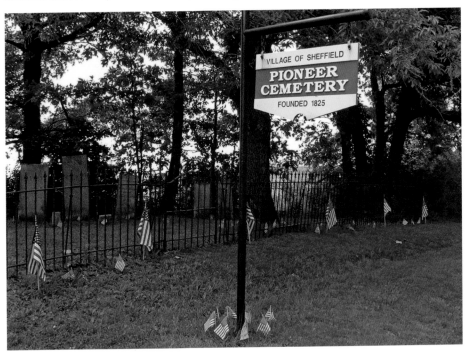

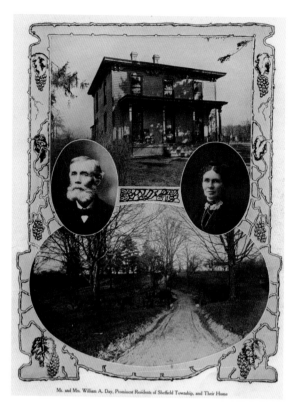

Mr. and Mrs. William A. Day, Prominent Residents of Sheffield Township, and Their Home

WILLIAM DAY HOUSE: William Augustus Day, grandson of Sheffield founder Capt. John Day, built this classic Italianate-style farmhouse on East River Road in 1879. Architect Elah Terrell planned the house with a formality and dignity not usually found in country farmhouses. The house sits on a rise far back from the road on a tree-shrouded lane overlooking French Creek. The house is still occupied by members of the Day family.

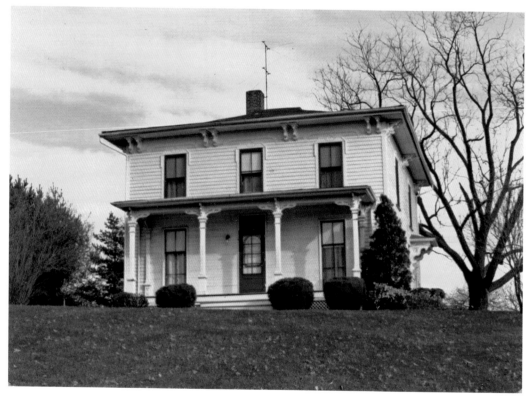

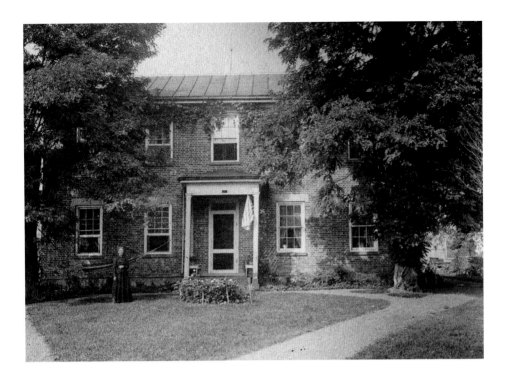

JABEZ BURRELL HOUSE: This late Federal-style farmhouse was built *circa* 1820 by Capt. Jabez Burrell on East River Road at the confluence of French Creek and Black River. Capt. Burrell and Capt. John Day of Sheffield, Berkshire County, Massachusetts, purchased the township from Gen. William Hart in 1815 and proceeded to found the settlement of Sheffield, Ohio. This house is the oldest home in Sheffield and the oldest brick structure in Lorain County.

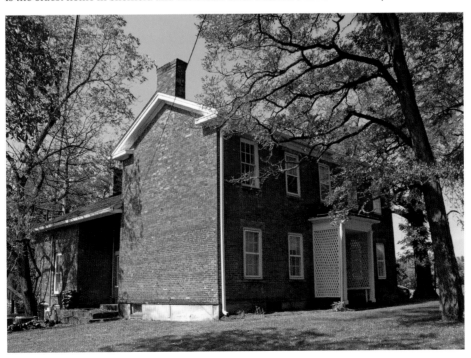

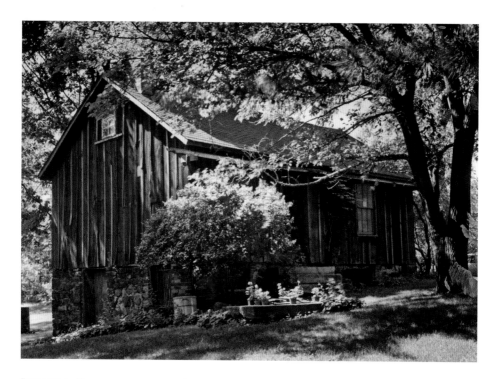

BURRELL CHEESEHOUSE: In the 1870s, Edward Burrell, grandson of Capt. Jabez Burrell constructed this cheesehouse on the family homestead and operated a cheese factory until about 1900. Annual production reached a peak of about 4,700 lbs. in 1872. The cheese-making process included pouring milk into large vats, heating it to 95° F, and precipitating the solids in the milk. The solids, known as curds, were partially dried and pressed into blocks of cheese.

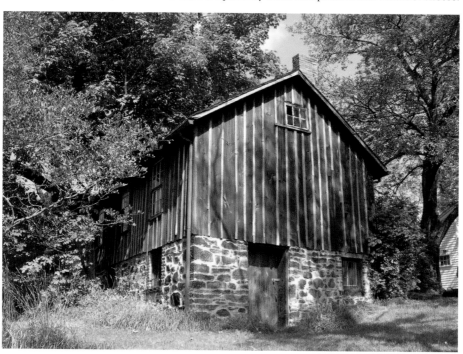

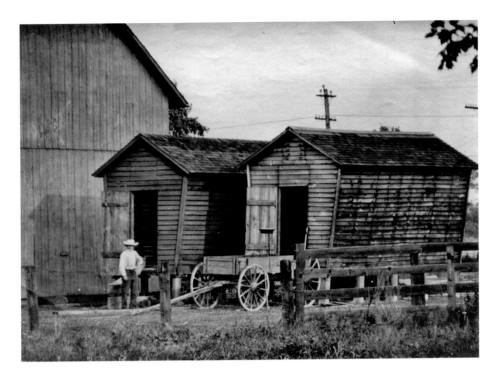

BURRELL FARM GRANARY: Over the years, the Burrell family constructed a number of granaries for the storage of their grain harvest. They were typically wood structures mounted on pillars to protect the grain from rodents and to keep the harvest dry. None of these are extant today, but the stone foundation of one of the more substantial granaries is shown below. The elaborate stonework consists primarily of sandstone, quarried nearby, and granitic fieldstone carried south from the Canadian Shield by glaciers.

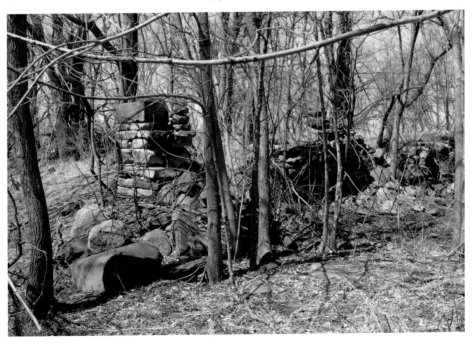

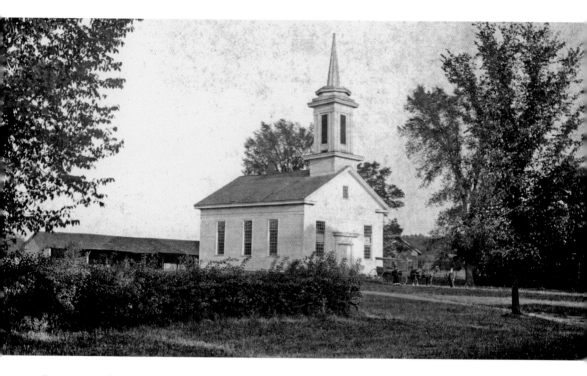

SHEFFIELD CONGREGATIONAL CHURCH: Built in 1852 to replace an 1818 log church, this elegant Greek Revival-style country church was located on East River Road, high on a bluff overlooking Sugar Creek. The elaborate bell tower and narrow spire rose 50 feet above the ground. A long row of horse barns for use by parishioners during inclement weather sat behind the church. The deteriorated building was torn down in the 1930s, but some of the foundation stones can still be seen.

SHEFFIELD DISTRICT NO. 1
SCHOOLHOUSE: The first
school in Sheffield was an 1817
log building on the south bluff
of French Creek. On the same
location, this 1880 red-brick
school was built near the
Congregational Church. Grades
one through eight were taught
on the main level, and the
district school board occupied
the basement. Demolished in
the 1930s after sitting idle once
Brookside School was opened in
1923, portions of the sandstone
block walls of the basement are
still standing.

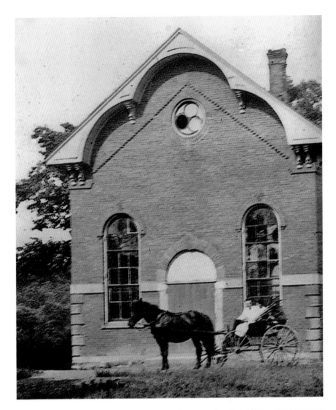

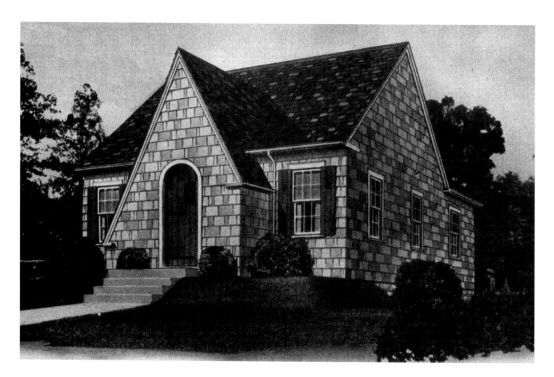

THE CLAREMONT: From 1908 to 1940, Sears, Roebuck & Co. sold about 75,000 package homes throughout the country. Several of these mail-order kit homes were built in Sheffield. This one on Day Street was built in the 1930s. The 1928 Sears catalog (above) advertised *The Claremont* at a price of $1,353, delivered by railway. Numerous exterior and interior options were available for each of dozens of home styles. A homeowner could save about 30 percent by self-assembling a Sears house.

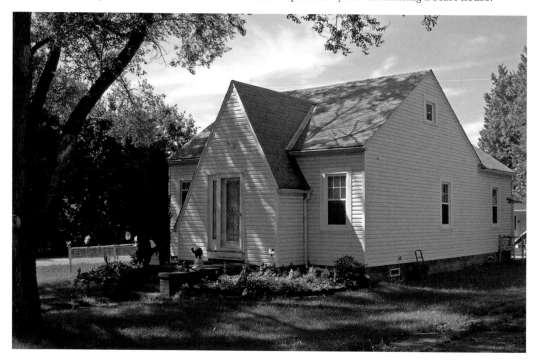

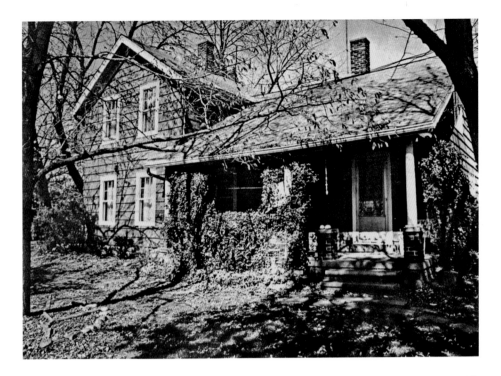

BEDORTHA-TRAXLER HOUSE: Douglas Smith built this Greek Revival-style farmhouse with a two-story front gable and one-story side wing for the Luther Bedortha family in the 1830s on Old Colorado Road. Edward Capp, a champion prize fighter from England lived in the house from 1861 to 1883. Members of the Traxler family have owned the property, called Stormy Acres, since 1884, starting with Henry Traxler and his bride Rose Urig.

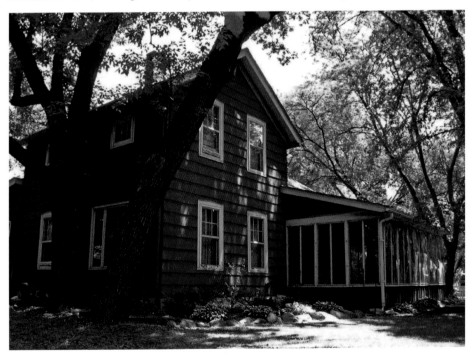

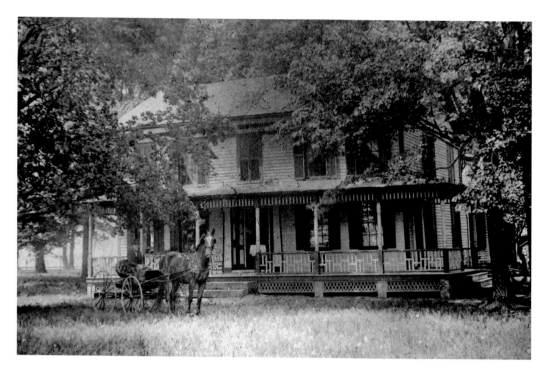

WILLIAM ROOT HOUSE: In 1816, as pre-teens William and his brother Aaron Root walked over 500 miles through the wilderness with their parents to start a new home in Sheffield. In 1850 William built this elegant Greek Revival-style home on a Lake Erie bluff at the foot of Root Road. William was a banker and served as Lorain County auditor from 1855 to 1861. The house once had a Victorian-style porch, but now the original façade has been restored.

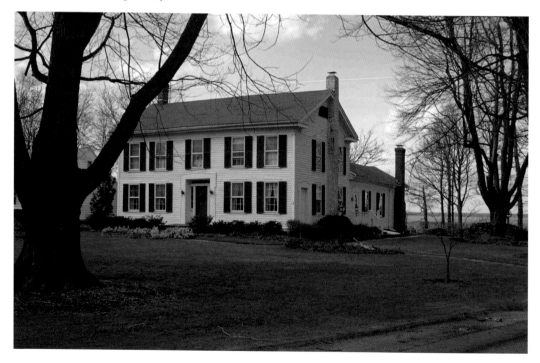

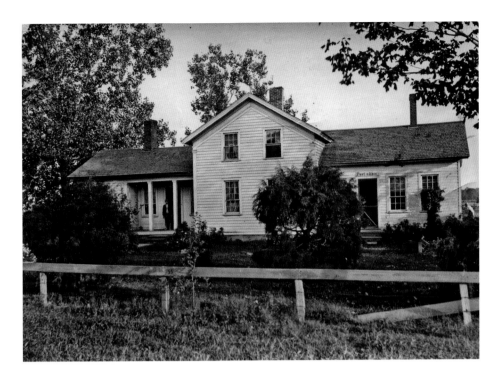

LAKE BREEZE POST OFFICE: The Lake Breeze Post Office was located in the home of Postmaster James Austin in the 1890s. This 1896 photograph shows the house to be a modified Greek Revival-style farmhouse with a two-story front gable and matching one-story wings on the east and west sides of the house. Austin was fond of hosting Sheffield's annual August picnic at his homestead. The old house was torn down to make way for the Mariner's Watch subdivision.

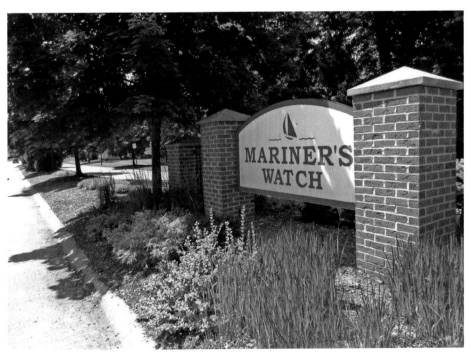

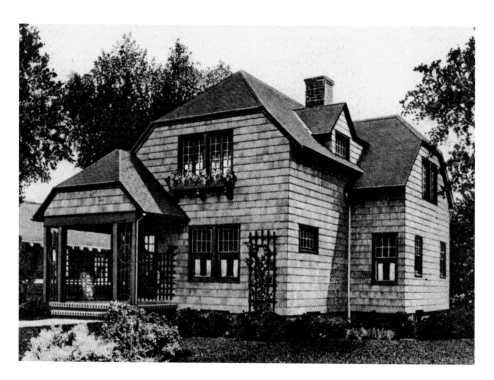

THE HATHAWAY: The above illustration from a 1926 Sears, Roebuck & Co. catalog depicts *The Hathaway*, a model style selected in 1928 by Charles E. Herdendorf, Sr., owner of the Standard Welding Company, for his new home on Lake Breeze Road in Sheffield Lake. The architectural style is Eclectic Tudor based on the high-pitched gable roofs, the use of cross gables, and tall narrow windows in multiple groups. The house once had an open porch that has since been enclosed.

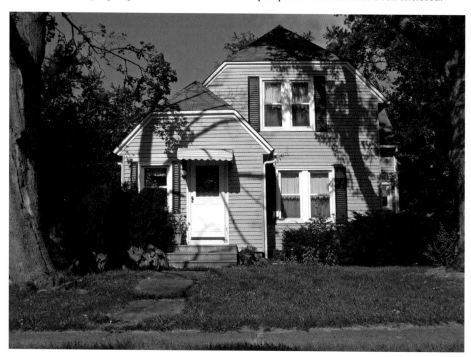

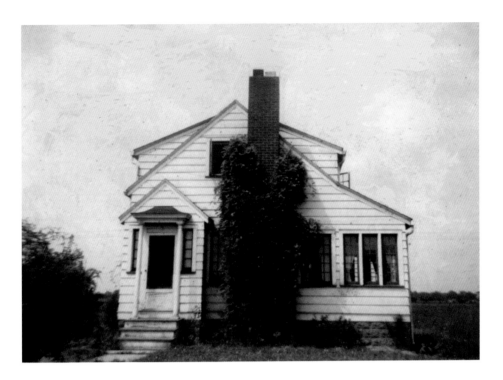

GAWN-COTTON HOUSE: Located on Lake Breeze Road at the intersection with Forest Lawn Avenue, this Folk Vernacular-style house was built *circa* 1910 by Thomas Gawn. He constructed it as a two-story, wood-frame farmhouse with clapboard siding. The house has a single front gable and northward projecting wing. The second floor dormers, shown in this above 1939 photograph were most likely added after the house was built. A massive brick chimney still dominates the front of the house.

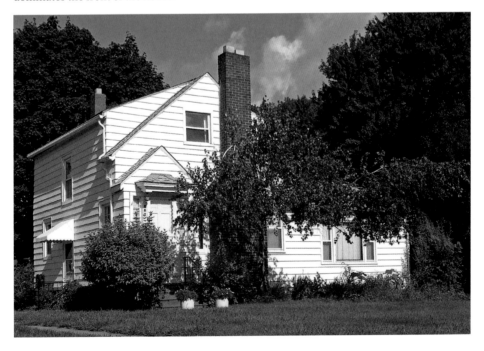

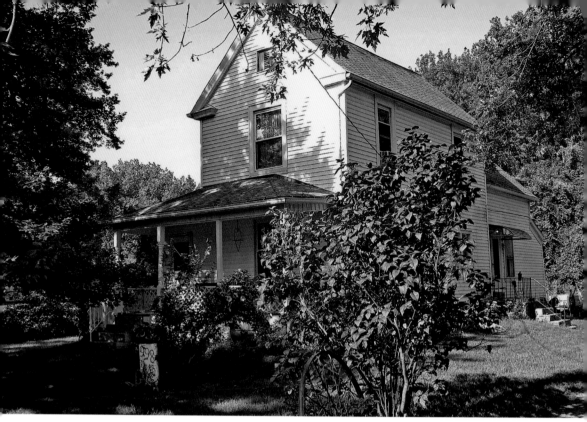

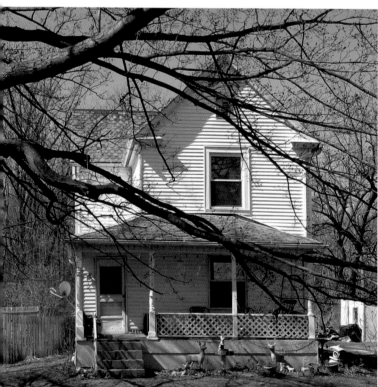

JOHN FOX HOUSE: The John Fox house on Lake Breeze Road was built in the 1840s and is believed to be the oldest homestead still standing on that road. This wood-frame farmhouse of Greek Revival style was likely built soon after John Fox settled at Sheffield in 1846. This front-gabled house still exhibits its original slate roof. The elaborate front porch may have been added at a later date, as homes of this style rarely had porches.

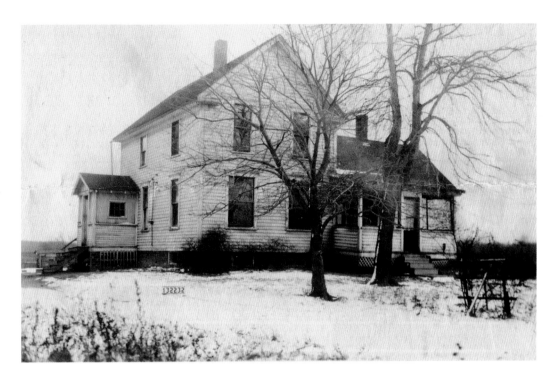

EDWARD KARNEY HOUSE: An early farmhouse on Lake Breeze Road, it was constructed in the Greek Revival-style by Edward Karney before 1857. The above 1943 photograph illustrates the primary features of this style that was popular for farmhouses in Sheffield during the period 1820-1860, such as a wide cornice board and partial return of the eaves across the front gable. The current owners, James and Joyce Toth have extensively modernized the original structure.

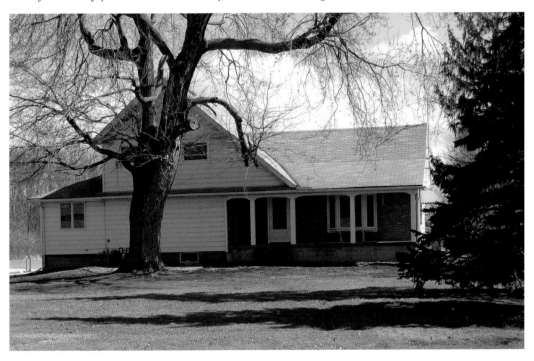

ST. MARK MONASTERY CHURCH: An attractive Serbian Orthodox church was built on Lake Breeze Road in 1988. It is modeled after a 600-year-old monastery church near Skopje, Macedonia. That church was completed in 1372 by Prince Marko, a hero of the Serbian people. When the church's design architect died, Sheffield architect Roy Kudrin stepped in to supervise the construction. The church leaders' vision is that the church will stand guard on the shores of Lake Erie for centuries, offering spiritual support.

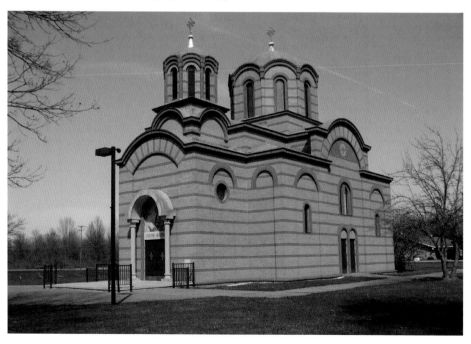

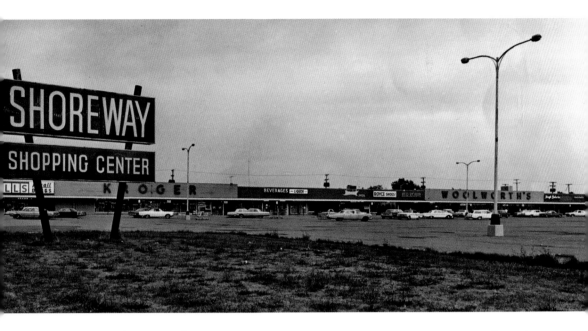

SHOREWAY SHOPPING CENTER: Built in the 1960s on the lakeshore at Lake Breeze Road, a variety of businesses have occupied the center. The Kroger Company was the first anchor grocery store, then in the 1990s a new Giant Eagle store was constructed at the south end of the parking lot, only to be replaced recently by an Apples Market. The City of Sheffield Lake now owns the center and has recently installed a wind turbine to generate power for exterior lighting.

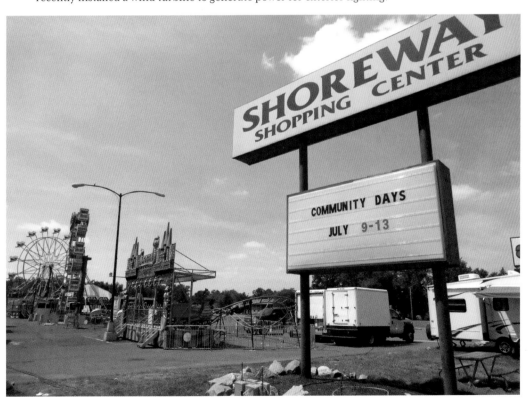

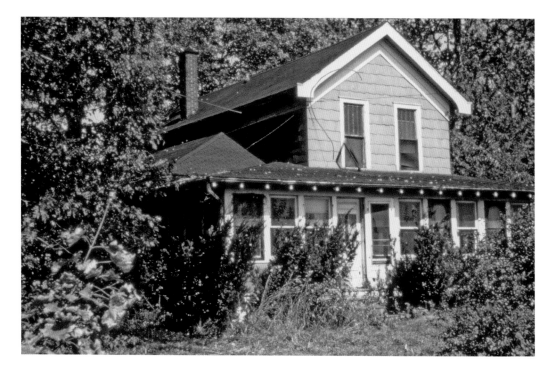

DOMONKAS LIBRARY: In 1964, the Domonkas Branch of the Lorain Public Library was built on the lakeshore near the foot of Lake Breeze Road with $100,000 donated by the Domonkas family. The site, originally owned by Joseph Fitch, was purchased by the city and leased to the Library Board. The above dilapidated house was demolished to accommodate the library. The 4,727 square foot building houses over 6,000 titles and has with a meeting room that seats 50 people.

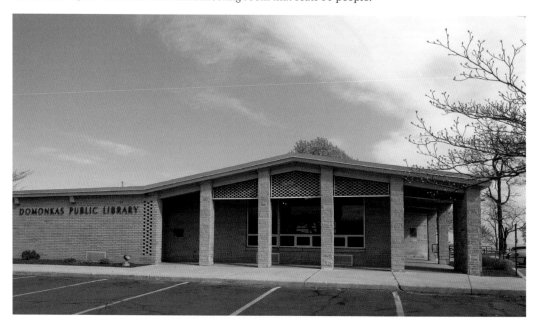

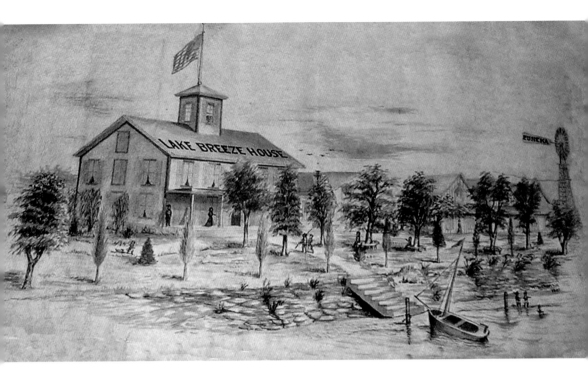

LAKE BREEZE HOUSE: In 1860 Jay Terrell operated this Lake Erie resort. An avid fossil collector, in 1867 Terrell discovered armor plates of an ancient fish in the shale cliffs. The fish lived 375 million years ago in the Devonian Sea that covered Ohio. Terrell presented specimens to Dr. John Newberry of the Ohio Geological Survey, who named the new species *Dunkelosteus terrelli* in honor of the discoverer. Today, the Lake Breeze Inn is located near where the old resort once stood.

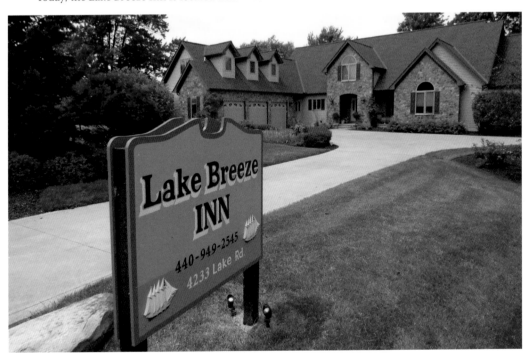

BROOKSIDE LANE HOUSE: Eclectic Tudor style was dominant for suburban homes in the early 1900s. This home on Brookside Lane in Sheffield Lake is an excellent example of the later part of that era. Features that distinguish this style include steeply pitched roofs, front-facing gables, diamond-shaped window mullions, and shingles on the gable façades. The house has changed little since 1972 (above), with the exception of replacing the diamond-shaped mullions and adding a deck over the garage.

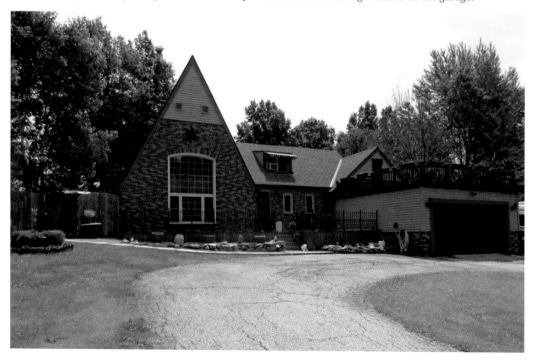

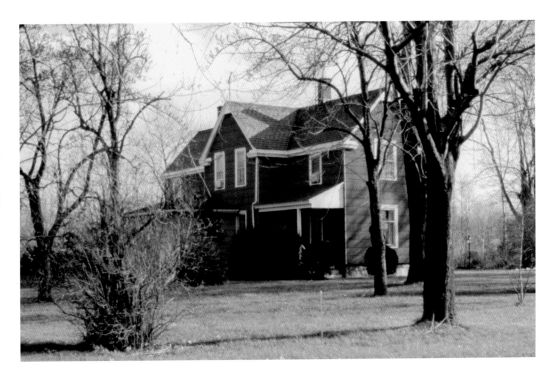

JOHN FERNER HOUSE: In the late 1800s the farmland on Harris Road from the lakeshore to Oster Road was owned Sebastian Ferner. His homestead, built on Lake Road has since been demolished (above view). In 1905, his son John married Margaret Biltz. As a wedding present, Sebastian gave the couple a plot of land at the corner of Harris and Lake Roads. The next year John constructed a charming Victorian-style home with a stone porch and fine interior detailing for his bride.

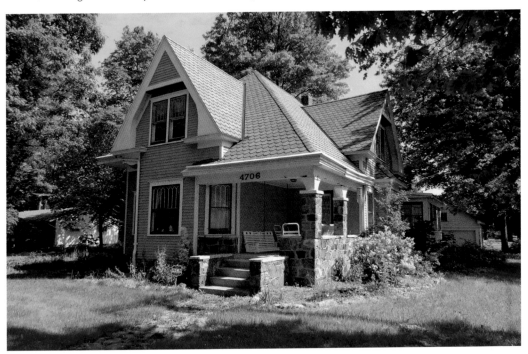

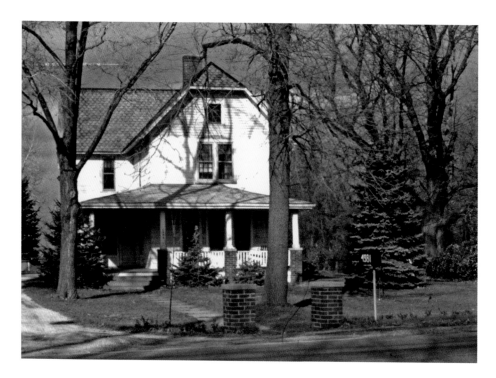

JEHIEL PALMER HOUSE: Built along the Lake Erie shore in 1871 by Jehiel Palmer, this Victorian-style house has the original slate roof. The current owners, Richard and Linda Ackerman have lived in the house for four decades. An immense white oak tree on the property, just east of the house, has a breast-high diameter of over six feet and an estimated age in excess of 200 years.

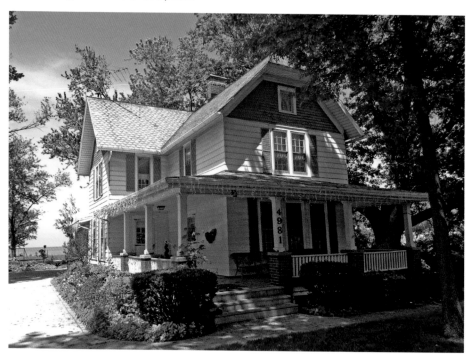

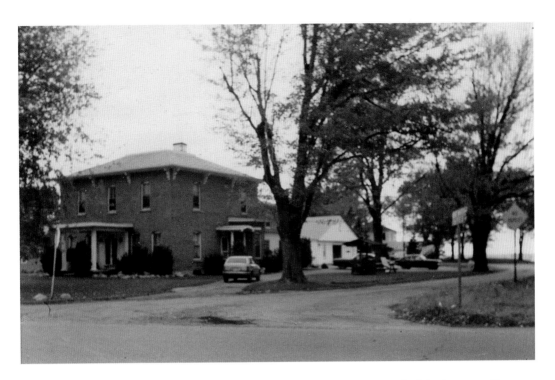

WOODRUFF HOUSE: Built *circa* 1880, this Italianate-style house on the lakeshore was the homestead of Lewis and Huldah Woodruff. The Woodruff's 99-acre farm was adjacent to Sheffield Township District No. 3 Schoolhouse, also built in the 1880s. Their son, Harry Woodruff, who eventually owned the house, was the first mayor the Village of Sheffield Lake when it was formed in 1920. The first airfield in the area was located on the mayor's farm at the southwest corner of Abbe and Lake Roads.

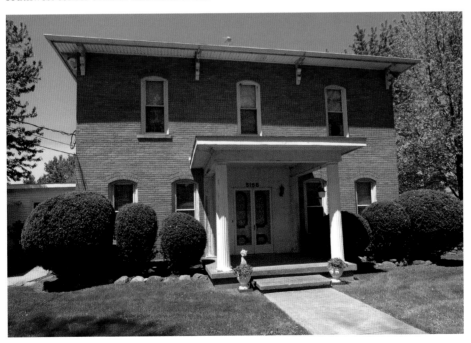

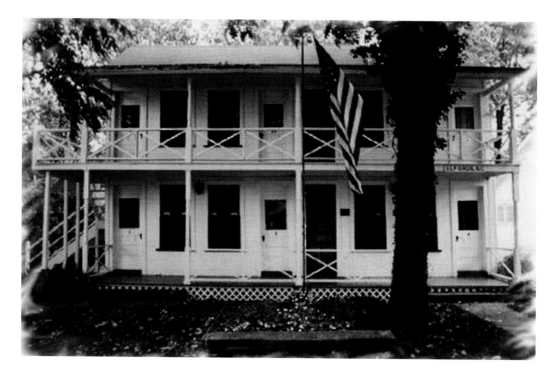

103RD O.V.I. REGIMENT MUSEUM: Members of the 103rd Ohio Volunteer Infantry Regiment in the Civil War formed an association in 1866 and established a permanent campground in Sheffield Lake in 1907. In 1910 the association built a barracks that was named "Elfordilno" in recognition of the work and donations of veterans Elsasser, Ford, Dillon, and Nodine. Once used as a dormitory for returning veterans and their families, it now serves as a regimental museum.

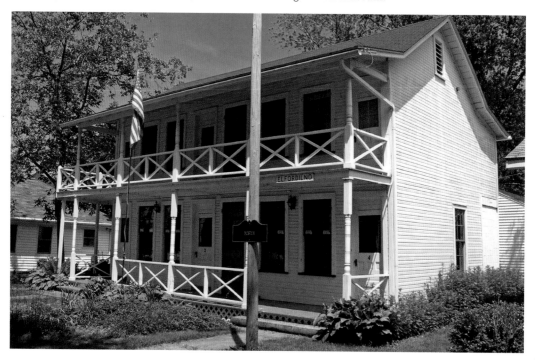

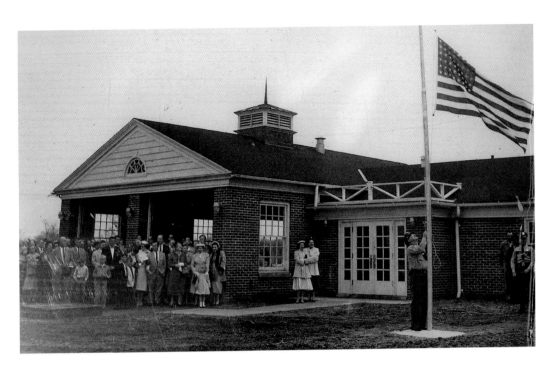

SHEFFIELD VILLAGE MUNICIPAL BUILDING: On April 28, 1957, the Village of Sheffield took a major step forward with the construction of a new municipal building to house the fire and police departments. Located within the village's James Day Park on Colorado Avenue, the building was designed by Architect Arnold Peterson. In 1999 the complex was extensively enlarged to include the mayor's office and a spacious chamber for the village council that can seat over 100 people.

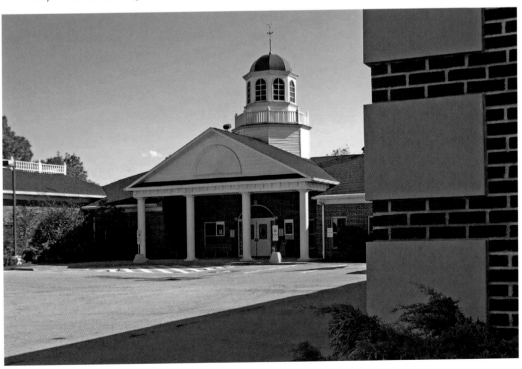

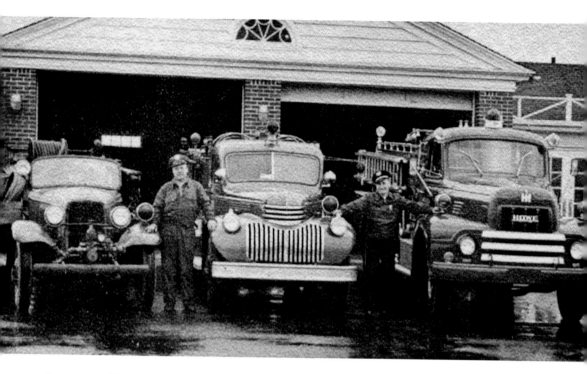

SHEFFIELD VILLAGE FIRE STATION: In 1957 Sheffield Village purchased a new Howe fire truck for $11,300 and new hoses for its other fire trucks. At that time the fire department had a chief, four officers, and 16 volunteer firemen. Currently the fire department is comprised of 25 firefighters and officers. In addition to being certified as firefighters by the State of Ohio, all are certified emergency medical technicians and paramedics. The department's newest fire truck is valued at $450,000.

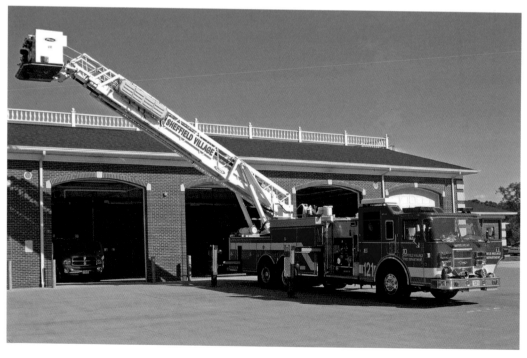

JAMES DAY HOUSE: James Day, one of Capt. John Day's sons, made the journey to Sheffield when he was only nine years old. In the 1850s he built this Greek Revival-style farmhouse on Colorado Avenue where he was known for hosting congenial social gatherings. After his death in 1896, his heirs arranged for Andrew Conrad to manage the homestead. In 1986 the house mysteriously burned and now the property is home to the French Creek Nature and Arts Center.

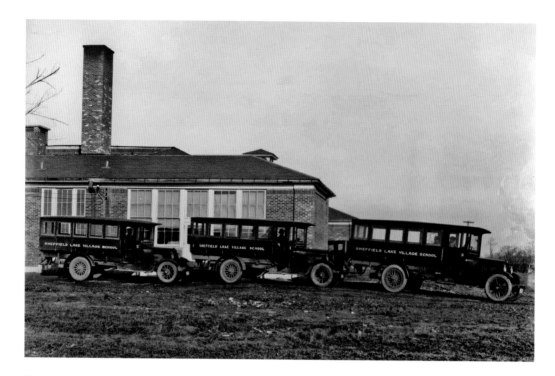

BROOKSIDE HIGH SCHOOL: Created by the centralization of schools, Brookside School opened in 1923 to serve grades one through eight for students on the east side of Sheffield Township. Three school buses transported students who lived more than a mile away. Located on Harris Road, it originally had six classrooms and a gymnasium. Reconstruction after the 1924 Lorain tornado added five more rooms. In 1969 a new high school was built across Harris Road and the old building became Sheffield Middle School.

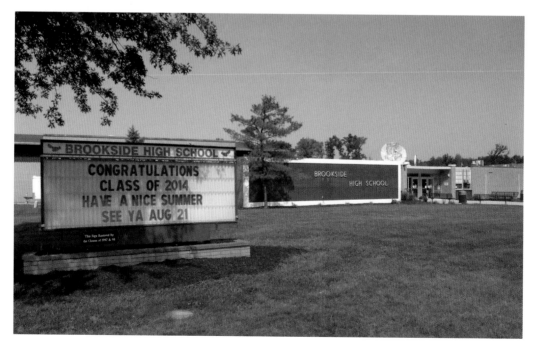

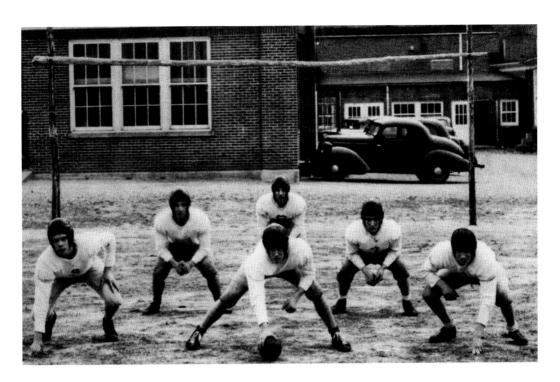

BROOKSIDE FOOTBALL FIELD: In the 1940s Brookside High School played 6-man football in league with other small Lorain County schools. The football field was simply an open field adjacent to the school with tree branches cut to serve as goal posts. The above 1944 squad marked the start of a 25-game winning steak that extended over five seasons. In 2007 a new Brookside High School football stadium was completed and named in honor of long-time coach Dick V. Sevits.

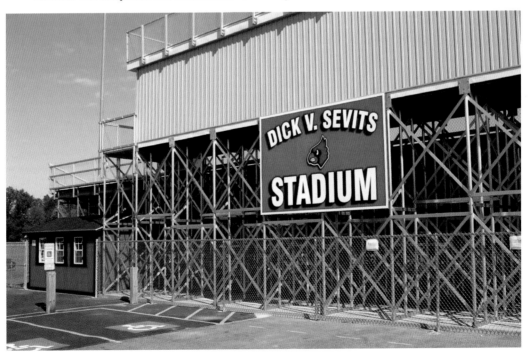

AARON ROOT GRANARY: Capt. Aaron Root built a Greek Revival-style farmhouse and an adjacent granary in the 1830s on Colorado Avenue. The farmhouse has been torn down, but Elmer and Sandy Klingshirn restored the granary in the 1980s. For years it served as an antique and gift shop, known as Sandy's Little Red Barn. Capt. Root is noteworthy as an early Great Lakes mariner and for his daring crossings of Lake Erie to carry runaway slaves to freedom in Canada.

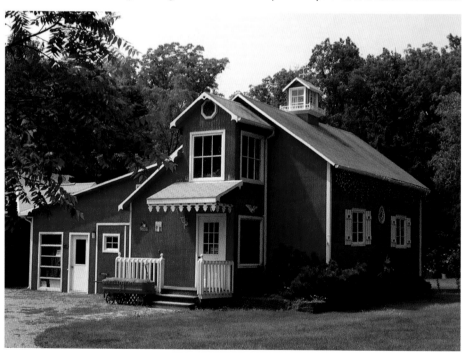

ST. TERESA CHURCH:
A fire on Sunday March 3, 1907, destroyed an 1850s wood-frame parish church during mass. Parishioners carried out pews, vestments, and the organ from the burning structure and watched in horror as the bell crashed to the ground. The above Gothic-style church was planned, constructed, and opened in time for Christmas the same year. The new brick church measures 40 by 74 feet in a Latin cross plan and continues to serve the Catholic community of Sheffield Village.

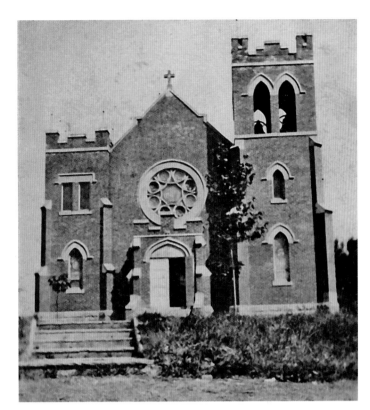

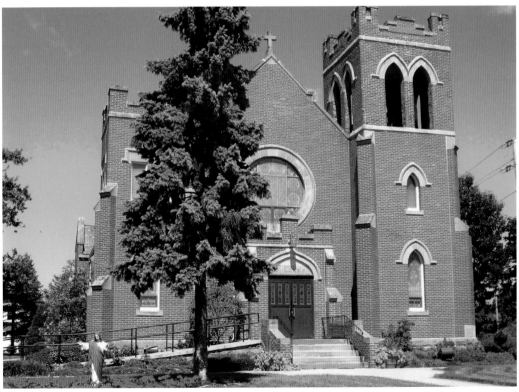

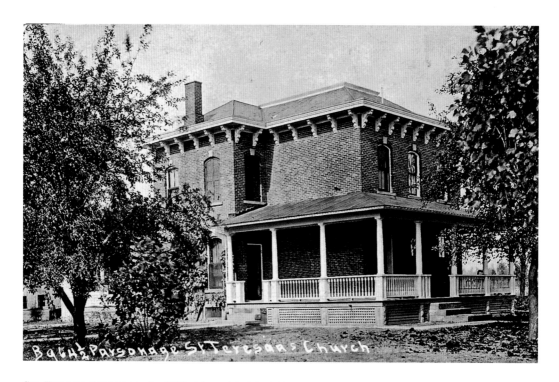

ST. TERESA RECTORY: In 1883 this red-brick Italianate-style house for the parish priest was constructed adjacent to the church for $2,700. Fr. Amadeus Dambach, born in Baden, Germany, was appointed as the first permanent pastor of the church in 1881 and the first to dwell in the new rectory. The building continues to serve as the parish office and domicile for the parish priest, Fr. Edward Smith.

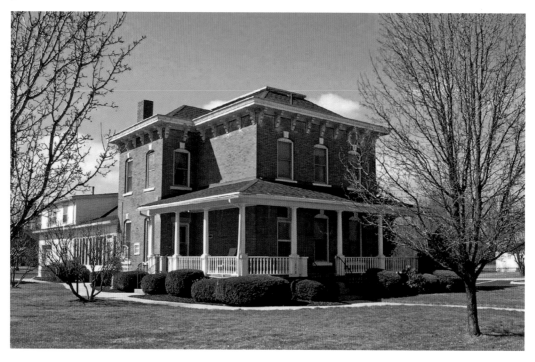

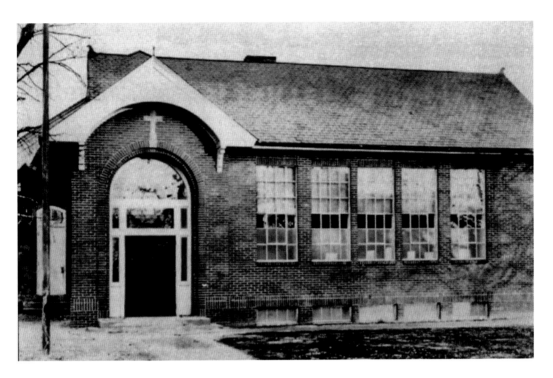

ST. TERESA SCHOOL: Originally built in 1880 as Sheffield Township District No. 7 Schoolhouse, in 1924 St. Teresa parish purchased the idle building for $100 and added a second classroom. However, from its beginning the school served the Catholic community. With the knowledge and approval of the Township School Board, lay teachers, the priest, and sisters taught classes at the school. Declining enrollment caused the school to close in 1967. The 1880 cornerstone has been placed in St. Teresa Cemetery.

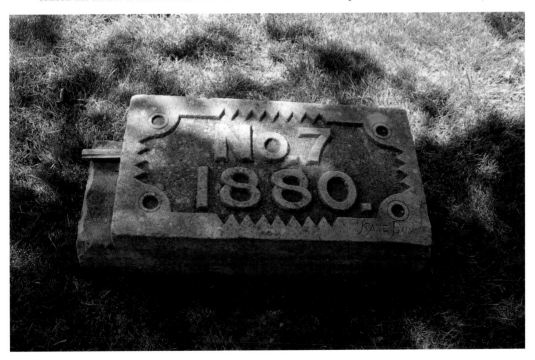

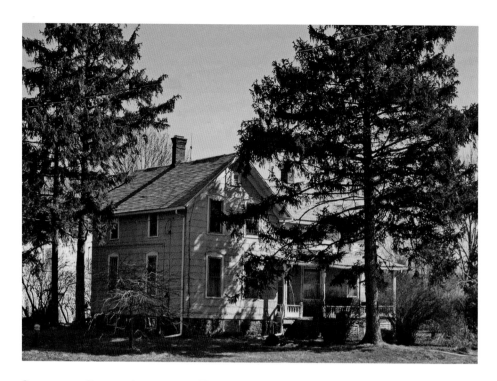

SCHWARTZ-BLAHA-ACKERMAN HOUSE: John Schwartz, the son of Bavarian emigrants who established a farm on Abbe Road in 1845, built this Vernacular-style house on the farm in the 1860s. The farm has been in the same family ever since, being passed down the generations on the maternal side of the family. The house plan is a front gable with a two-story side wing. An elaborate porch with decorative railing and roof supports graces the front of the house.

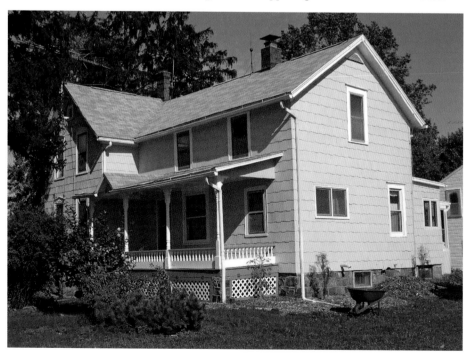

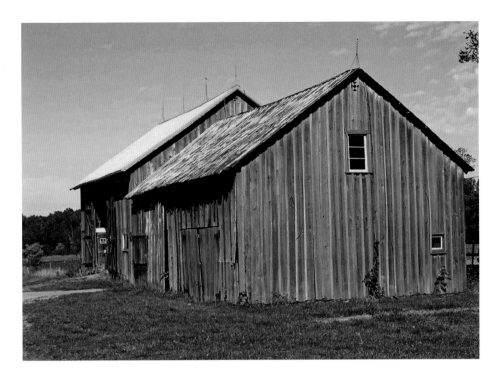

SCHWARTZ-BLAHA-ACKERMAN FARM: The barns on this farm are over 150 years old, dating back to the early days when the land was cleared for tilling. The buildings are still used for livestock, poultry, and hay storage. The Maltese cross-shaped opening in the gable was cut to allow owls to enter for control of rodents. This is one of the last remaining comprehensive farms operating in Sheffield. Today the barns also house a suite of vintage tractors.

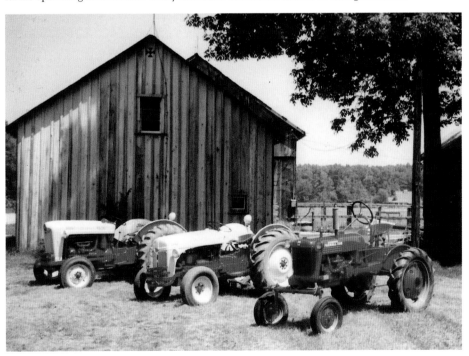

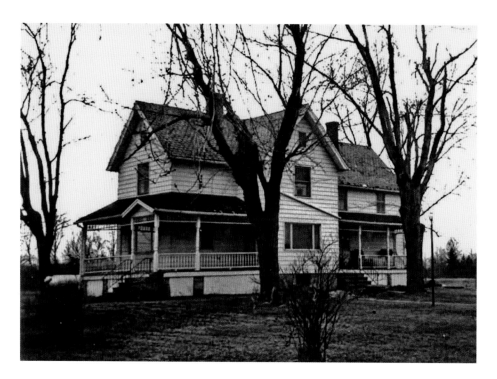

ANTON JUNGBLUTH FARMHOUSE: A descendant of Bavarian emigrants, Anton Jungbluth built this Vernacular-style farmhouse in 1900 on Abbe Road. A prominent feature was an expansive front porch that extended across the east side of the house and one-third of the way along the north side. Decorative railings, roof supports, and overhead trim highlighted the porch. The house was torn down when it was 100 years old in anticipation of a railroad expansion that never materialized. Now, only soybean fields remain.

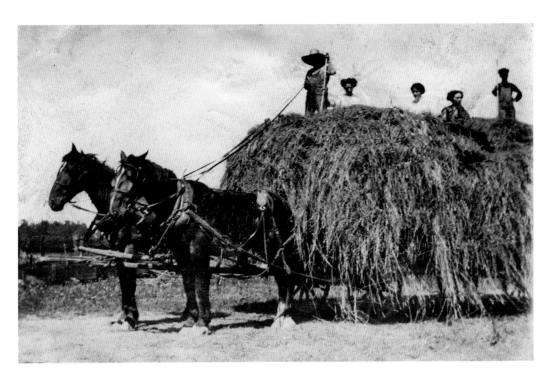

SHEFFIELD HARVEST: In the late 1800s Sheffield farmers, like the Anton Jungbluth family, harvested hay with a team of horses that pulled a hay wagon to which a hay loader was attached. The loader was put in motion by the turning of its wheels as it was drawn along behind the wagon. Today modern equipment, like this John Deere automatic soybean harvester, is used. Soybeans and sweet corn are the major crops currently being raised in Sheffield.

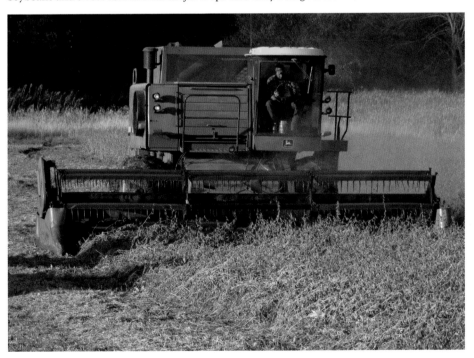

ACKNOWLEDGEMENTS

The author is indebted to the many members and friends of the Sheffield Village Historical Society who have contributed material to the Society's collections, thus making the preparation of *Sheffield Through Time* possible. Most of the historic illustrations presented in this book were obtained from the digital archive of the Society. Other major contributors of historic images include the Domonkas Branch of the Lorain Public Library, Lorain County Historical Society, and Lorain County Metro Parks. Ricki C. Herdendorf provided editorial assistance throughout the preparation of this work. Contemporary images are the work of the author.